DRAWING WITH Colour

KL-145-166

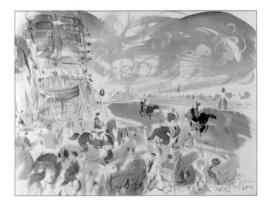

WITHDRAWN FROM STOCK

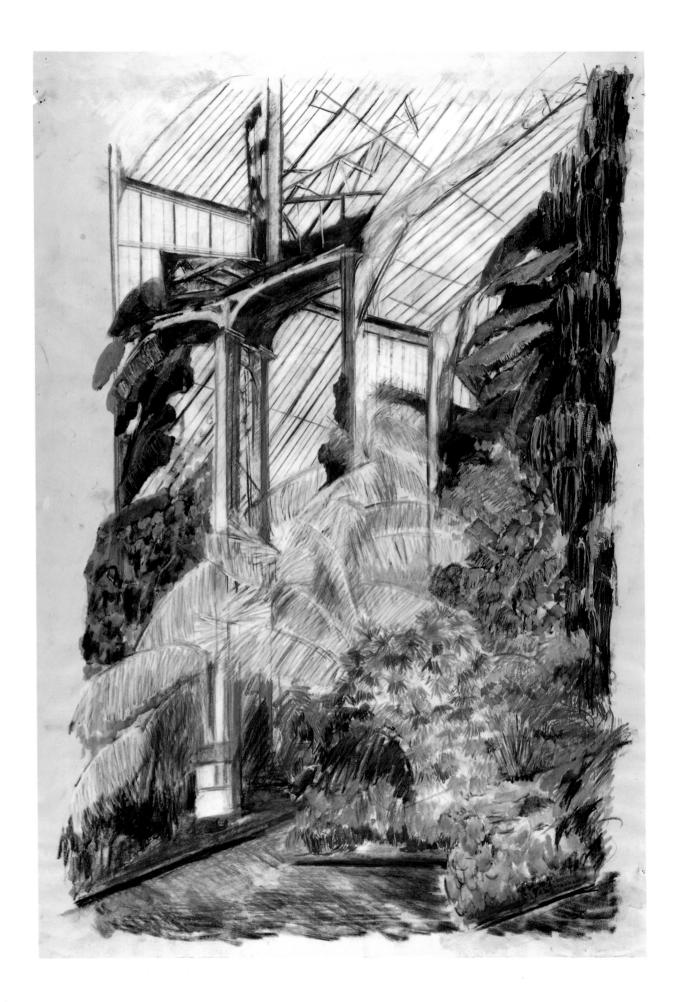

DRAWING WITH COLOUR

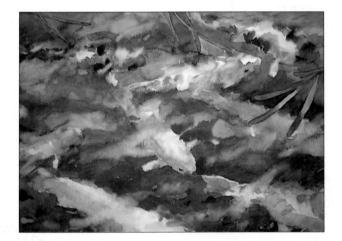

Judy Martin

Copyright © Quarto Publishing plc 1989

First published in Great Britain in 1989 by Studio Vista an imprint of Cassell Publishers Limited Artillery House, Artillery Row London SW1P 1RT

All rights reserved. This book is protected by copyright. No part of it may be reproduced, stored in a retrieval system, or transmitted in any form or by any means, electronic, mechanical, photocopying or otherwise, without written permission from the Publishers.

> British Library Cataloguing in Publication Data Martin, Judy, 1950-

Drawing with colour.

1. Colour drawings. Techniques. Manuals

I. Title 741.2 741 MAR

ISBN 0-289-80025-0

This book was designed and produced by Quarto Publishing plc The Old Brewery, 6 Blundell Street, London N7 9BH

Project Editor Hazel Harrison Designer John Grain Picture Research: Angela Gair and Elizabeth Mellen Special thanks to Tom Robb

> Art Director Moira Clinch Editorial Director Carolyn King

Typeset by Text Filmsetters Ltd., London and QV Typesetters, London Manufactured in Hong Kong by Regent Publishing Services Ltd Printed by Leefung-Asco Printers Ltd, Hong Kong The Illustrations on pages 1-5 are as follows:

PAGE 1 Off to the Start by Jake Sutton PAGE 2 The Temperate House, Kew Gardens by Daphne Casdagli PAGE 3 Koi Carp by John Hargreaves OPPOSITE Still life (detail) by Jane Strother

Contents

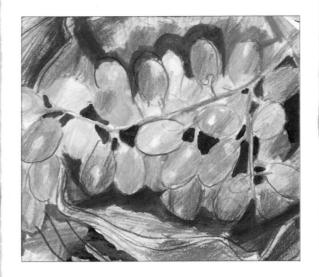

 $INTRODUCTION \cdot 6$

CHAPTER ONE · 14 The Properties of Colour

> *CHAPTER TWO · 30* Physical Colour

CHAPTER THREE · 54 Descriptive Colour

CHAPTER FOUR · 84 Atmospheric Colour

CHAPTER FIVE · 106 Expressive Colour

 $INDEX \cdot 140$

CREDITS · 144

Introduction

Drawing has traditionally been seen as an activity secondary to "major" art forms such as painting and sculpture — a learning method or process of preparation that leads to a more polished visual statement. In this role, it is associated with economy of means and materials — dictionary definitions of drawing lay emphasis on picture-making with line and tone, sometimes identifying basic materials such as a pencil or pen. Some even include the words "without colour", and if you look at any large collection of drawings in a book or exhibition you will find that linear and monochrome techniques are dominant. Colour was sometimes employed in drawing in the past, but mainly as a means of decorating or elaborating a monochrome image. The free expression of colour values and the contribution of colour to an image were considered the natural preserve of painting rather than drawing techniques.

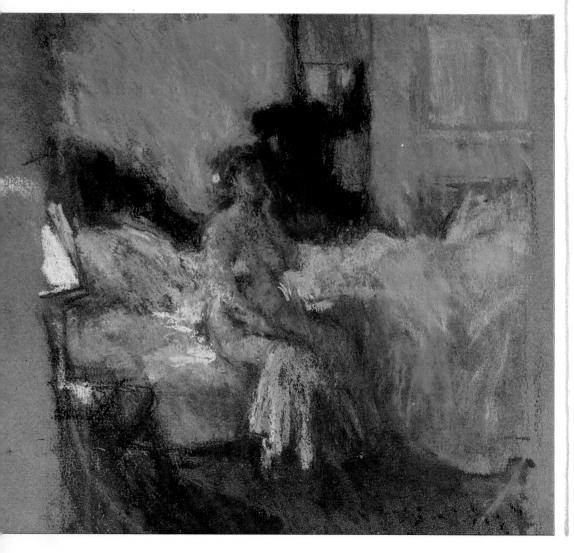

LEFT A delicately tinted life study by Bernard Dunstan exemplifies the traditional technique of working with loose, grainy pastels on toned paper. The interior light is beautifully captured with high-key pinks and yellows against green, sepia and umber shadows on the mid-toned background colour.

Two things have changed the way colour is used both in drawing and painting. One is the idea of beginning with colour, rather than structure in the form of line and tone, and making it one of the essential themes of an image. This was a concept which only began to be fully explored in the late nineteenth century, but since that time colour has been acknowledged as a basic element in image-making, not something to be superimposed as a surface effect. This development was a result of certain artists, notably the Impressionists, finding different ways of looking at the world. To them it seemed that colours, and the effects of colour in light, had a central role in methods of rendering immediate perceptions of form and space. The second factor was related to technical developments in colour chemistry: the new synthetic pigments introduced at this time produced a far greater range of colours for artists' use.

This range has continued to increase, which is of great importance to the ways we use colour in drawing and painting today. Traditional colour-drawing materials such as paints, pastels and chalks have been joined by a vast array of coloured

RIGHT "The Monastery of Mar Saba", a chalk and oil sketch by David Bomberg, conjures a vivid sense of place from lines and streaks of bright colour on a warm brown ground. Fine draughtsmanship is evident in both the structure of the composition and the sensitivity of line. pencils, crayons, markers and pens which exist simply to be colourful. All these materials are convenient, direct sources of colour, and artists in many fields are giving them increasingly serious attention.

WHAT IS DRAWING?

In order to provide a useful approach to the subject of colour in drawing, the chapters in this book are based on the different ways in which we can all develop keener colour perception and learn to interpret colour "behaviour" to express our personal responses through the technical means available. Ideas about what drawing is and why artists do it are interwoven throughout the chapters, and are implicit in the many styles of the colour work illustrated. But it is worthwhile taking time here to analyse briefly the purposes and functions of drawing as a creative activity.

Drawing is physical evidence of a thought process, a means of re-creating a visual impression, whether this is seen in the real world or in the mind's eye. The traditional role of drawing as structural definition gives it a place in all kinds of artistic expression — some painters "draw" with dense and fluid oil paint on huge canvases; some sculptors "draw" in three dimensions with stone or steel.

The disciplines represented by drawing are common to artists in all fields of work; it can be as important to a designer or sculptor as to a painter or illustrator, providing a quick and expressive way to record or develop an image or idea. Many drawings are produced as stages in a working process rather than as significant studies in their own right, but drawing is also now a primary method of achieving a final image, intended to be a self-contained artistic statement.

There is no single definition of drawing that encompasses all the creative elements involved, but any book that sets out to say something useful about colour drawing must impart a sense of what is meant by "drawing", and place certain limits on the content and range of ideas. For practical reasons, this has meant creating boundaries that are to some extent arbitrary, and dealing with concepts which are occasionally rather vague. Part of the book's intention is to loosen preconceptions about both colour and drawing, to open up the range of what colour drawing can be, as well as showing what is being done.

Delineation, or use of line, is often cited as one of the main elements of drawing, and one that makes it characteristically different from painting, where there is an emphasis on mass and solid colour. Linear and calligraphic qualities are certainly an important aspect of many of the images and ideas throughout the book, partly because several of the main media of drawing have points and edges with which the colour is laid, rather than a fluid or spreading character, but this does not

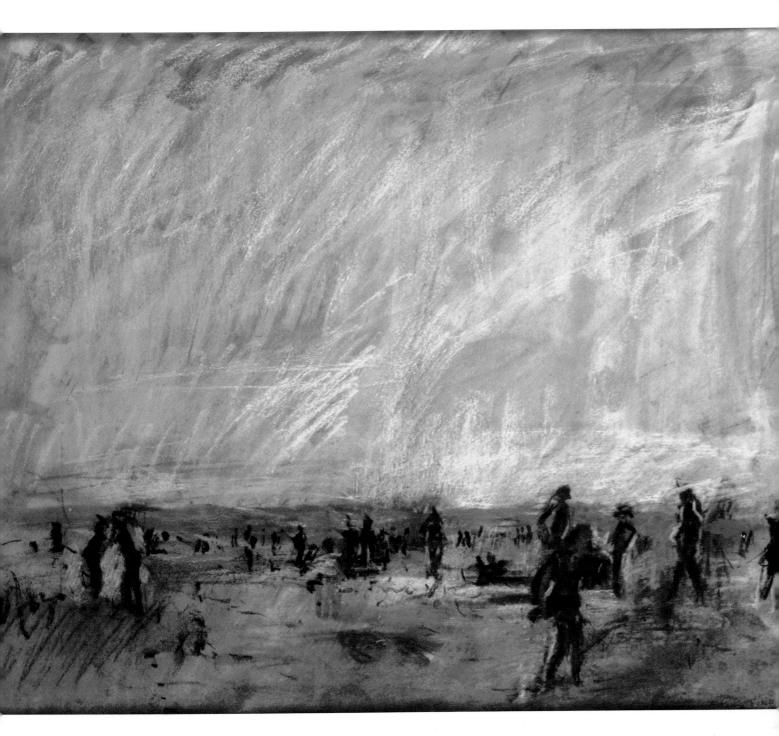

eliminate the possibility of making a drawing in terms of mass and volume rather than line, using blocks of colour and gradated effects of light and shade.

MATERIALS AND TECHNIQUE

Pastel, crayon and coloured pencil are readily available and convenient media for colour drawing. They are dry media produced and handled in stick form, and their own shapes and textures affect the ways in which they are used. They tend to introduce a linear element, even when the colouris shaded into solid or gradated areas. Markers and felt-tip pens can provide a ABOVE The textures of this pastel drawing by Anthony Eyton form a record of the artist's technique in creating the atmosphere of the crowded beach. The detailed activity described in the foreground is subtly emphasized by the vigorously calligraphic treatment applied to the large area of open sky, the two elements being separately defined but integrated visually and technically. crisp, hard-edged quality, but their fluid ink also spreads easily across a surface, so to some extent they form a bridge between conventional notions of drawing and painting. The same applies to coloured drawing inks applied with a pen or a brush.

Paints of all kinds are included here as drawing media for colour work which raises the question of how we would define one image as a "painted drawing" and another as a painting. However, there are so many essential areas of common ground between painting and colour drawing that the two activities are bound to overlap to some extent, and preoccupations are always similar: much of the information in later chapters about visual analysis and rendering space, form, light and colour is applicable to any two-dimensional art medium.

Techniques in any creative work are largely dictated by the characteristics of the chosen medium. For instance, drawing with coloured pencils involves a gradual building process, without which you cannot develop blocks of colour and complex mixed-colour effects. Drawing with a brush, on the other hand, may involve sharply defined linear qualities or broad washes of fluid colour. The use of coloured papers, too, enables the artist to work on a background of solid colour or to construct parts of the drawing as colour blocks. The important thing is to become familiar with the properties of your materials and the ways in which these can be used to re-create your visual impression of the subject. Some of the examples in this book are fully "painted", but express some essential connection with basic drawing processes. This only serves to demonstrate how broadly the activity of drawing informs creative works of different kinds.

A lot of drawings are relatively small-scale — convenience and practicality are part of the appeal of drawing methods. Also, the gestures used in drawing are typically contained in movements of the hand, wrist and lower arm. Limited scale is not an inhibiting factor in image-making but a creative one, especially when using colour, as the concentration of drawn marks within a small area can produce dynamic tensions and rhythms within the image. On a large scale, it is difficult to control the interactions of the marks, particularly when these are created with a material or instrument which is itself of limited size, such as a pencil, pen or pastel stick.

Another factor that determines scale is that paper is the material most commonly used as a support for drawing, because available paper sizes dictate to some extent the scale of drawn images. This is a practical element that we usually take for granted, but it is significant. Some artists go to a lot of trouble to obtain huge paper sheets or make them by pasting together smaller pieces, but it is usually easier to accept a given scale and work to it.

RIGHT Work by David Hockney has had an important influence in stimulating a new appreciation of coloured pencil as a major drawing medium. His portraits and figure studies have demonstrated how these simple tools acquire great sophistication and versatility in the hands of a master draughtsman. Within this full-length portrait study, Hockney uses the subtlety of the medium to weave the muted green and grey tones of the clothing, and at the same time demonstrates the much more vivid effects of light and colour produced by mixing scribbled and hatched strokes of pure hues and pale tints. The illumination of the face is achieved not only by the strong highlight showing the white of the bare paper, but also by touching in the glasses with clear yellow and linking this to mixed colours in the shadow behind the head. This colour block contrasts with the stronger red and purple shadows used to model the side of the face turned away from the light. Bold blue and purple streaks on the socks make a vivid flourish of the leg and foot angled towards the viewer.

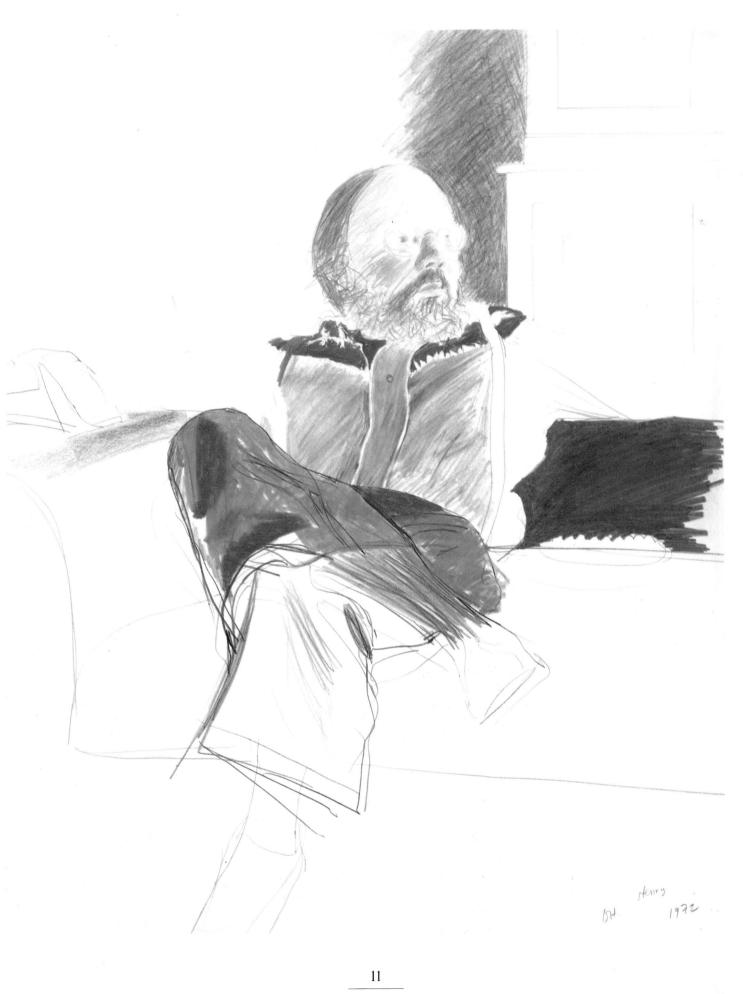

DRAWING WITH COLOUR

No two people perceive colour in quite the same way: it is an area that produces distinctive personal and subjective responses. It is one of the vital creative factors that provides opportunities for every artist to create an original, individualistic form of expression. But it is not always easy — colours can make such powerful statements that it is often tempting to seek safety in playing them down instead of making the most of them.

Nor do the materials always help as much as you might think. The richness of colour you see on the display stands in the art suppliers is an appetizing prospect, even if you buy quite selectively. The materials seem to offer limitless potential, but it can be difficult to make them work in ways that release this potential in the form of a colourful, descriptive image. Perhaps the colours may mix and turn muddy on the surface, losing their individually vivid hues, or perhaps the technical ideas that you have about using the materials don't quite work in practice. The awful sense that a drawing has begun to fail, and that the more you put in, the worse it will get, is common to everyone at some time, whether professional or amateur. But it is less likely to happen once you have a clear idea of your intentions in any given project, and have gained an understanding of the materials you intend to use.

This book provides all sorts of avenues for thinking in and working with colour to produce the kind of drawing that you hoped to achieve. Its contents range from colour exercises designed to sharpen your perception and make you more at home with your materials to projects aimed at helping you to produce finished drawings that carry out your intention. This may be to create an accurately descriptive colour rendering, or it may be to achieve a vigorous personal expression of colour. No single image or example is a "right" or "wrong" way to deal with colour in drawing, so no hard-and-fast rules are going to be supplied. The intention is to demonstrate that drawing with colour is a wide-ranging, exciting and enjoyable activity, and to assist you in finding your own way to use colour more ambitiously and effectively. RIGHT Olwen Tarrant brings out the pure colours in the landscape, enhancing the balance of hues and tones to create a vividly descriptive composition. The drawing is worked in pastel on a heavilygrained, dark-toned paper. The artist develops form and texture by varying the pastel strokes, in some areas building dense masses of colour, in others exploiting the linear qualities of the medium. Where the grain of the paper creates an effect of broken colour, the brighter hues are intensified by the contrast with the underyling dark tone.

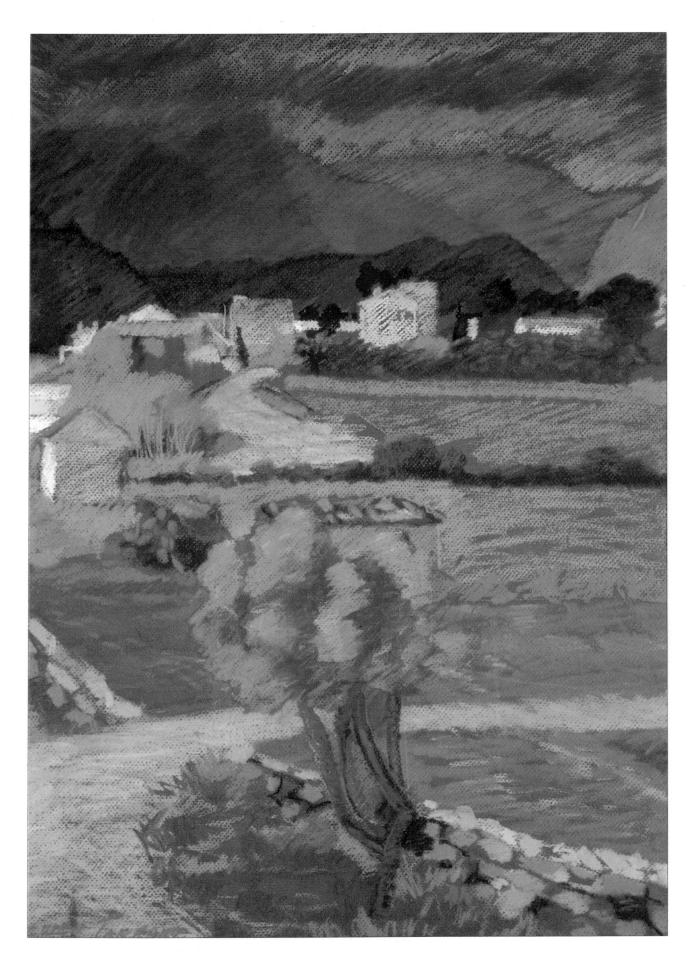

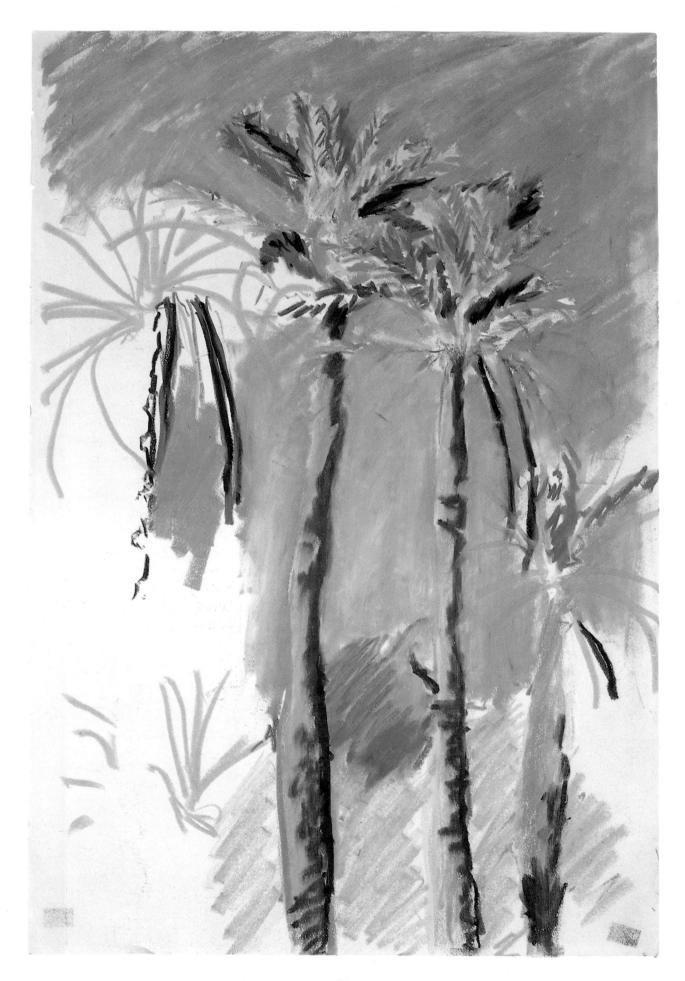

The Properties of Colour

LEFT In keeping with the tropical subject, Ashley Potter's oil pastel drawing of tall palms plays sunshine yellows and citrus greens against clear blues and mauves to produce a vibrant effect. This drawing was the basis for a silkscreen print, in which a more formal design was schemed with brilliant colour. Our responses to colour are instinctive and wide-ranging. We use it as a means of recognition and analysis — it helps us to define space and form — we use colour cues as invitations or warning signals, we appreciate its purely decorative functions and respond consciously or subconsciously to its emotional appeals. When we now watch re-runs of old television programmes made in black and white we can appreciate how impoverished the world would seem without colour. It takes considerable creativity to make a "colourful" statement in monochrome, though it can be done, and there is plenty of evidence in drawings, prints, film and photography to show this. On the whole, though, colour is a more stimulating medium, and we have learned to use it with great variety and invention.

The sheer wealth of colour in natural and manufactured objects, together with the variations created by form, surface texture and effects of light and shade, can make it very difficult to unravel the distinct and manageable aspects of colour values BELOW To capture the character of a landscape it is often necessary to use the colour cues of the natural model as a basic register that the artist can manipulate in terms of colour interactions. Jane Strother picks out the contrast of yellows and warm browns against cold blues and purples in this open, windswept view. when you start to make a drawing or painting. This chapter looks at the various elements involved in the phenomenon of colour and our perceptions of it, and examines the ways in which these may influence our ability to make images. It is not concerned with actual techniques of colour rendering, which are explored in the later chapters. The intention is simply to point to different aspects of our awareness of colour, thus providing a brief grounding for a practical approach to colour drawing.

WHAT IS COLOUR?

Colour is an effect of light. The range of colours that we see in a given context depends upon the quality of illumination created by the available light, but the colour is a real phenomenon, not an illusory or transient effect. Each material or substance that we perceive as having a particular colour is reflecting certain light wavelengths and absorbing others, and its ability to do this is inherent. A red object, for example, does not suddenly turn blue under the same light conditions, but it will not appear red if it is not receiving illumination that includes red light wavelengths.

White light contains all colours, and it is under white light that you see what might be called the "true" colour of an object — what artists term local colour. When a beam of white light is passed through a glass prism it separates into its component colours, and can be projected on a surface as clearly defined bands of colour. This effect was first studied in the seventeenth century by Sir Isaac Newton, who identified the bands of the colour spectrum as red, orange, yellow, green, blue, indigo, violet — a list that has become familiar to generations of children as the colours of the rainbow. The science of light and colour has moved very far since Newton's time. The spectrum of coloured light is estimated to include about 200 pure hues within the visible range, although not all of these are readily distinguishable by the human eye.

For the artist the practical points at issue are the visual sensations of light and colour and the ways in which these are experienced. As this book is mainly concerned with the practicalities of colour perception and how what is seen can be expressed through drawing, concentrating on complex ideas about the "behaviour" of colour in light is not a priority. However, there is one important principle that should be carried with you in your colour work. Light is the source of colour. It can thus be said that the artist working with colour is always trying to capture effects of light, but is doing so using materials that contribute their own physical weight and density. Colouring materials that are solid and textured behave quite differently from coloured light. Because white light is composed of colours, a certain combination of col-

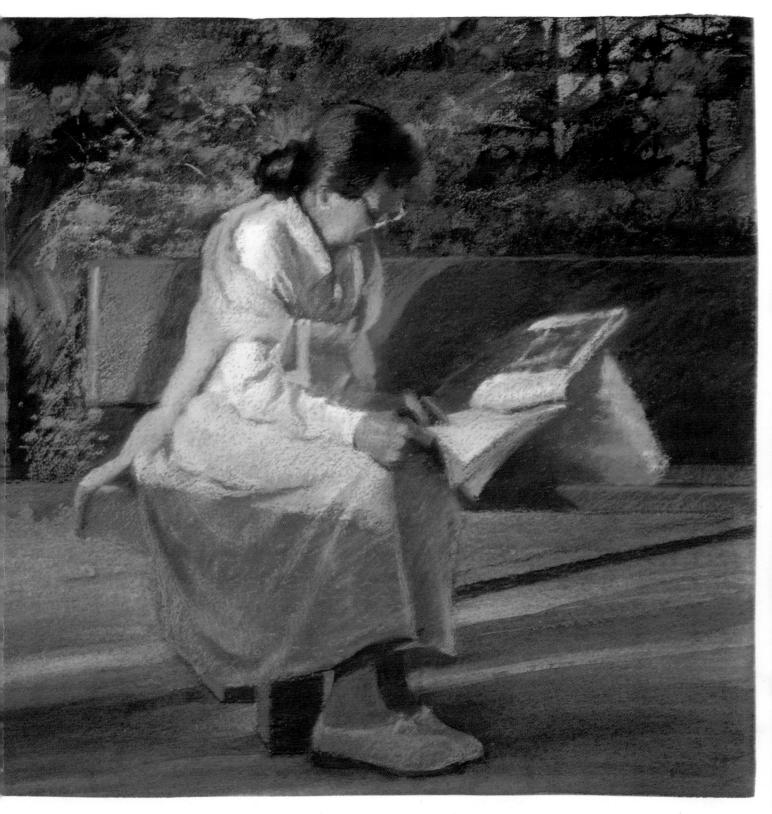

oured lights makes white, but with drawing or painting materials, the more colours that are applied, the more colourful or darkly veiled becomes the surface effect. The artist is dealing with substantial elements, and must learn how they can be used to create equivalents of the insubstantial effects of light. ABOVE Sally Strand exploits the broken texture of pastel, achieving an extraordinary quality of illumination through her control of pure colour values and the full tonal range.

RESPONSES TO COLOUR

We perceive colour in physical terms by the action of light on the rods and cones in the retina of the eye. The cones distinguish hue while the rods register qualities of lightness or darkness. By some estimates, a person with normal colour vision is capable of identifying up to ten million variations of colour values. The conditions known as colour blindness include several forms of incomplete colour perception — an inability to distinguish red and orange hues from yellow and green is perhaps most common — and there are rare cases of people who see only in monochrome.

Whatever the scientific evaluation of our visual capacities, none of us can be sure that we see colours in exactly the same way as anyone else. It may be possible to measure the colour range of light entering the eye, and to check the efficiency of the physical receptors, but this says nothing of the sensation of colour experienced by an individual. Our responses to visual stimuli are "processed" by the brain, which can add memories, associations and its own inventions to the purely physical information we receive.

It is accepted that colour has an emotional impact, although it is not possible to qualify the precise effects of each

colour. Such implications are acknowledged in everyday speech by phrases such as "seeing red" or being "green with envy". The origins are not clear — why, for example, should blue be the colour of a melancholy mood, as in "feeling blue"? However, even when there is a widely accepted colour association of this kind, this does not make it a reliable factor in visual terms. Matisse's *Red Studio*, for example, is not an angry painting, even though it is flooded with red, and plants, real or depicted, are not associated with jealousy because their leaves are green. Colour is a relative value in image-making, and its pictorial significance depends upon other aspects of the composition as well as on the context provided by the subject. Expressing mood and emotion through colour is a relatively abstract exercise more dependent on colour interactions than on external influences and associations.

The creative use of colour can be affected by all sorts of personal preferences, with complex and often obscure origins. Attempts to use colour as a personality indicator have uncovered widely varied influences. One person may dislike a colour because it is associated with an unpleasant occurrence, while people with entirely different characters and tastes may all come to like a colour because it is fashionable

ABOVE LEFT A large-scale drawing can be a good medium for releasing inhibitions about colour work. This image is derived from a display of brilliantly coloured garden flowers. Working with acrylics and pastels on a paper sheet 82×112cm (33×45in), Judy Martin allowed the drawing to develop freely and abstractly. and widely promoted. Familiarity with the colours in a particular environment can make them seem independently attractive.

Most of us are fairly conservative about the colours we live with, and many people prefer to dress mainly in restrained or neutral colours accessorized with brighter accents. We usually look for harmonies, which leads us to choose restricted colour combinations often containing more muted than pure hues. The same is true on a wider scale — many people might like the idea of putting a red sofa into a white room, but few would choose to paint their living room walls bright scarlet.

Some colours seem more difficult to deal with than others. Orange and purple can seem hard and artificial, oddly, since garden flowers present many rich and subtle shades of these hues. Blues and greens commonly seem more sympathetic, which might be to do with their predominance in nature. Yellow is a colour that many people will not wear, as it is considered unflattering and sometimes brash; yet it is also associated with sunshine and a cheerful atmosphere and Van Gogh demonstrated very effectively how well it can work as the dominant colour in painting. ABOVE This image is the result of colour "doodling", an exercise begun by Judy Martin purely as an abstract investigation of colour relationships. It was limited to the range of colours supplied in a box of soft pastels, which covered all the six main colour "families" (see pages 21–4). The image emerged simply from trying out all the colours and textures of the pastels and gradually organizing the different areas of the composition.

CREATIVE COLOUR

This brief introduction to aspects of colour perception explains some of the reasons for the difficulties people find in working confidently with colour. There is no set dogma about colour which an artist can learn and use — colour values are always relative: to each other, to their physical context, to expressive uses and to the range of possible responses. This makes it hard to "manage" colour. But it is one of the most stimulating elements we have to work with, and it need not be overwhelming, although it sometimes seems so.

Even if a given view were to contain all the ten million colour variations you have the potential for seeing it would not be either necessary or desirable to render them all accurately in a drawing, even if it were possible. You need to find a way of sifting the essentials and explaining them visually in your own terms. You may have to work on sharpening your colour perception and your ability to analyse various colour effects — from the brilliance of broad expanses in landscape to the tiny shifts of colour seen reflected from a white teacup. Thus you will collect a greater range of information from which to select the precise means of rendering your chosen effect. There is also a great wealth of

RIGHT This drawing is a colour exercise produced by picking up visual impressions from the changing pictures on a television screen. The changes are so rapid, there is no point in attemping a representational "copy". There is time only to note down abstract properties about shape and colour. At an early stage (above) the marks are random. As the drawing gradually acquires form, choices can be made that enhance the emerging image.

BELOW Frances Treanor's pastel drawing combines vibrant colour values with inventive design, placing an already complex image within an intricately patterned frame. As well as dividing the composition into a network of colours, she has used the textural quality of the pastel to introduce yet another layer of visual interest. This approach requires great confidence, as its success depends on maintaining the dynamic presence of each aspect of the design.

experience provided by the work of other artists, both past and present. Their responses to colour and the means they have found to represent them are legitimate sources of insight into perceptions that may parallel our own.

COLOUR CHARACTER

If we can see millions of pure hues and tonal variations of colour, the range of colour values that we can identify and use is more or less infinite — an alarming prospect. This huge number of colours, however, can be grouped into distinct "colour families", and these are actually very few. We can categorize colour sensations as belonging to one or another family, distinguishing colours that have a quality of redness from colours which tend towards greenness, for example, even though these are not always pure red or pure green hues.

In practical terms, artists' colours are grouped as six standard hues — red, orange, yellow, green, blue, purple. These represent the three primary colours, which cannot be created by colour mixing — red, yellow and blue — and three secondary colours — orange, green, purple — which can be mixed from pairings of the three primaries. The broader variety of pure hues are theoretically capable of being mixed from different combinations of the six — degrees of redorange, yellow-green, blue-green, blue-purple and so on. Also related to all pure colours are the different tonal values of lightness and darkness, increasing the total range of colour values.

Theories that analyse and predict various aspects of colour relationships assume fixed colour values. But what is confusing is that there is no actual standard for the fixed colours-no precise definition of, for example, primary red - and different theorists have come up with different ways of analysing the relationships. To use colour in drawing you must evaluate the actual colour in your materials on the basis of your experience. This is not to say that theories have no place; they have produced some useful guidelines on organizing colour relationships which can be put to practical use. These include ideas about the "presence" of each individual colour and its interactions with others that are based on observation, but it is worth bearing in mind that they do not constitute set rules of colour behaviour. Part of the excitement of working with colour lies in the feeling that it is still possible to make it do the unexpected.

Drawing With Colour

COLOUR PROFILES

Colour interactions are all relative, but gaining a sense of colour as an entity in its own right helps to focus your perception of colour values in material objects. It is important not to take for granted your response to colour or your ability to analyse it in real terms. To begin with, take a look at the intrinsic character of each colour, its sources and associations. The colour "profiles" below focus on the origins, range and family characteristics of colours, and are a preparation for considering the more abstract aspects of colour relationships. **Red** A powerful colour — even in small quantities it readily catches the eye, and the brightest and purest hues of red dominate most other colours. The extensive colour range of reds passes from the dark-toned, earthy red-browns and rich red-purples to the lighter values of orange-reds and clean, vibrant pinks. Strong reds can have a violent presence, but also an inviting, enveloping density. Red occurs frequently in nature. Original sources of natural red pigments included insect dyes, making crimson and carmine, earth for red ochre, the mineral source of vermilion, cinnabar, and plant dyes providing a range of madders. Modern synthetic pigments have supplemented these natural values of red to create a rich variety.

Orange Standing between red and yellow in the colour spectrum, orange is secondary to both these colours and shares some of their visual characteristics and emotional impact. Its values readily merge into yellow, red or shades of warm brown, leaving true orange as a colour of relatively limited character. Yet natural orange hues seen in fruits, flowers and foliage, minerals, gemstones and warmly coloured metals such as copper and bronze are rich and various. There have been few good natural sources of pigment or dye, and orange is usually a "manufactured" colour, yet it is commonly associated with elemental resources such as energy, warmth and light.

Yellow This colour occupies a narrower band of the spectrum of coloured light than the others. It is highly reflective and naturally light-toned, providing a sense of illumination. Whereas most colours will darken with increasing saturation, yellow tends to appear brighter as it gains intensity. The words used to describe different qualities of pure yellow are taken from natural contexts — sunshine yellow, lemon yellow, golden yellow. Earth colours such as yellow ochre and raw sienna represent the darker values, but the darker, heavier tones tend to "slip out" of the yellow family, to be categorized as light browns or muddy greens. When there is a strong bias towards another hue, yellow is quickly perceived instead as pale orange or citrus green, depending on the particular bias. BELOW Colours do not have fixed, independent values in drawing. Any individual colour is affected by another, whether this is complementary (see page 23), similar in value, or achromatic. These colour exercises illustrate such different combinations.

RIGHT Jake Sutton's colourful regatta actually contains relatively few colours. The effect comes from the strong values of primary and secondary lues – red, blue, yellow, orange, green – applied in translucent watercolour. There are no complex mixtures or muted tones, so the image has an unrestrained clarity well suited to the mood of the subject. The liveliness of the ioose brushwork adds to the atmosphere, but the contrast made by the sudden sharp detail of the line of bright flags is a clever touch.

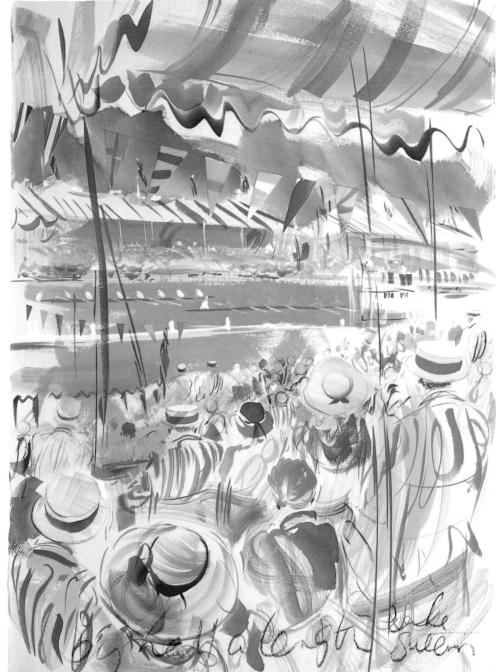

Green It is impossible to dissociate green from the idea of life and growth in nature, but in fact there are few natural sources of green pigment, and the many values of green colouring agents, including those used in artists' materials, have been chemically developed. In physical terms, the eye focuses green easily and it is thought to be a restful colour, a sensation underlined by its perceived naturalness. Green hues are extremely various, beginning with those close to yellow at one end of the range and ending with rich blue-greens at the other. Like the yellows, the true greens are given descriptive names from nature such as emerald green, grass green, sap green. **Blue** As a primary colour and one with a strong presence and a wide range of hues and tones, blue tends to rival reds for dominance, showing little of the influence of other primary or secondary hues. Dark and light values of blue are often equal in intensity to its pure hues. An inevitable association with natural elements credits blue with qualities of airiness, coolness and peace, but it is also a vivid and decorative colour in nature, seen in some of its richest tones in flower colours and flashing out from the otherwise dull plumage of some common birds, effects quite different from the pervasive clear blues of open sky. Lapis lazuli, the original source of ultramarine, was a rare and valued mineral pigment, and

other blues came from plant dyes such as woad and indigo, but synthetic pigments have greatly increased the range. Purple A secondary, or mixed colour, purple combines properties of blue and red, the strongest primaries, so it can provide a powerfully rich colour sensation. The colour range includes hues which we describe as purple, violet, or mauve, each suggesting a slightly different quality. Violet is represented in the spectrum of coloured light. Purples, of limited availability from natural sources, are typically manufactured colours which did not figure largely in the artist's palette until the late nineteenth century. Purple itself is a naturally darktoned colour, light purples usually being achieved by mixing with white. The word mauve suggests softer shades with a bias towards the gentler reds, such as carmine, madder and the paler pinks, while descriptions such as lilac or lavender, used as colour names, are purely associative.

Achromatic colours Chroma is the quality of "colourfulness" in colours. Black, white and pure greys are described as achromatic, having in theory no colour bias. In terms of colour science, black is the result of all colours in light being absorbed by a surface. White results from the total reflection ABOVE A landscape in watercolour and coloured pencil by Jane Strother is described in subtly related colours. The deep blues are the pivot of the scheme: on one side they pass into warmer purples which in turn give way to hints of redbrown; at the other end of the range, the blues merge into the soft greens of the receding countryside, reverting to truer blues at the distant horizon line. of all colours, and a neutral grey is seen when all wavelengths of light are absorbed to an equal degree. In real terms, there is usually three to five per cent inefficiency in the absorption or reflection of light, so we are often able to distinguish different qualities of whiteness, blackness or greyness that also include a hint of colour value.

THE COLOUR WHEEL

The colour wheel, linking the six colour types in a circular formation, is simply a graphic device for explaining the basic relationships of primary and secondary hues. Placing the colours within a segmented circle gives an arrangement in which each primary colour faces, in the opposite segment, a secondary that is composed of the other two primaries. Thus by going round the wheel you can identify the relationships of adjacent or harmonious colours, and by working crosswise you can see the opposing pairs of primaries and secondaries known as opposite or complementary colours. Red is complementary to green (blue + yellow), yellow to purple (red + blue) and blue to orange (red + yellow). Between the segments occur more complex mixtures that create the range of subsidiary hues — such as red-orange, yellow-green, blue-purple and so on.

In addition to hue — a specific colour value such as red or red-purple — the colours also have tone — a value of lightness or darkness. Colour intensity refers to the strength of the hue, which may be "devalued" or "fully saturated". Hue, tone and intensity are coexistent within any given colour value. Various attempts have been made to produce three-dimensional diagrams and models describing the relationships of these different aspects of colour, but these can be more confusing than instructive.

This is the colour circle traditionally associated with artists' pigments. Colour relationships in light, however, are quite different. The primary colours in light are not red, yellow and blue. There are other synthetic colour primaries too, such as those used in printing inks, but contrasting such different systems is not useful here. However, when you use, for example, coloured pencils or pastels to overlay red with blue to create purple, or yellow and blue to produce green, there is some degree of devaluation which varies with the quality of the materials. The influential factors are the apparent hue and tone of each colour in the mixture, the purity and strength of the pigment content, and the presence of a substance used as a binding medium. For this reason, the colour wheel should be viewed only as representing the basic principles of colour interaction - actual effects of colour relationships and mixtures must always be seen in the context of the specific drawing materials.

Contrast and harmony Colour theory states that complementary colours are mutually enhancing. That is, in any complementary pair each has the effect of intensifying the other. This applies to mixed hues as well as to the basic primaries and secondaries. Taking as an example the complementary pairs red and green, and yellow and purple, it follows that the mixed hue red-purple is complementary to yellow-green.

The enhancing effect is an important one in the representation of colour values. As soon as you put two colours together they form some kind of interaction. Red and blue in

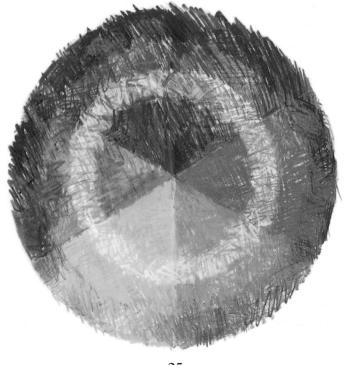

RIGHT The colour wheel was devised to explain graphically the relationships of pure hues, showing the three primaries red, blue and yellow — linked by the secondary colour mixtures — purple, green and orange. Adjacent colours are related, opposite colours are complementary. This example is constructed with strokes of pastel colour: it shows the circle of pure hues and also tonal variations from light values in the inner ring to darker tones on the outer border.

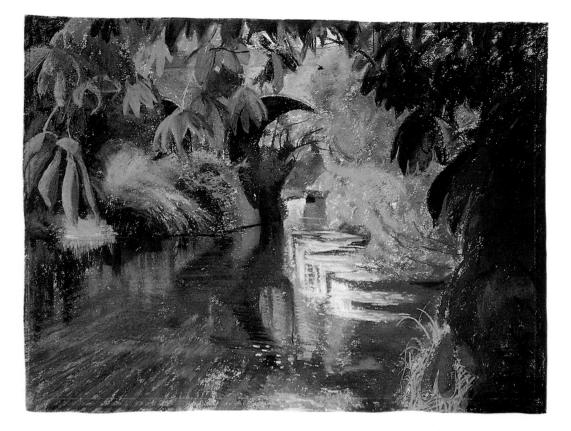

ABOVE In natural subjects, the complementary colours of red and green are often seen in values that combine harmoniously, having a gently enhancing effect on one another rather than a strongly reactive relationship. John Plumb uses soft reds and greens to describe a river view overhung with foliage. There are many subtle shifts of colour in the greens, assisted by the merging of grainy pastel strokes, and these are nicely offset by the harder pale blue tone in the reflection of sky on water. some forms create just as strong a colour contrast as red and green. Introduce orange, and you have an affinity between the two hues from the red-dominant side of the colour circle and a strengthened contrast in their opposition to the blue. The combination of two related colours with one opposing colour value is a reliable basic scheme for colour in composition. It produces a well-balanced effect, especially when the relative tonal values are also well disposed.

You sometimes get a particularly dazzling effect from combinations of red and green, or blue and orange, as these colours are also relatively close in their tonal relationships. All four when seen as characteristic pure hues occupy the middle tonal range, although orange is in the lighter range of mid-tones and blue in the darker end of the scale. The pairing of yellow and purple is less reactive in colour terms because yellow is a naturally light colour while purple is relatively dark. If you adjust tonal balance to bring them closer together the colour quality will inevitably be devalued, the yellow becoming muddy and the purple pinkish or clouded. Tonal values also have an effect on the apparent "weight" of a colour: light-toned colours seem lightweight, darker tones more heavy. In terms of physical materials though, colour weight is also influenced by the transparency or opacity of the coloured surface.

Interesting effects of harmony or contrast can be created by altering the expected tonal values in a colour combination. Dark yellow against a very pale mauve tends to be somewhat

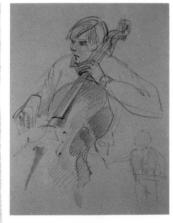

ABOVE Ellen Gilbert's coloured pencil sketch of a cellist is quite tightly structured, but has a strong sense of movement. There is a well-judged balance between line and tone that provides an economically descriptive image. This would work well in monochrome, but the artist's decision to employ a subtle change from blue to brown tones has given additional depth to the portrayal.

The Properties of Colour

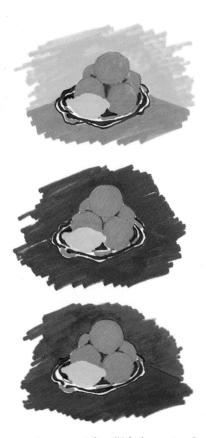

ABOVE RIGHT This still life of oranges is an exercise in complementary colours, using the vibrant combination of blue and orange, given a little variety to counterpoint this pairing by the inclusion of a single lemon and the pattern detail in the plate. The still life was drawn in pastel on orange paper, so that the colour modelling of the fruits had to be gauged against the strong background hue. Careful examination of the oranges will show that the lights and shadows contain pure yellow and red, although the underlying colour pulls the different values together. The felt-tip sketches (above) investigate the different impressions of the composition if the effect of complementary contrast is weakened by adjusting the colour relationships.

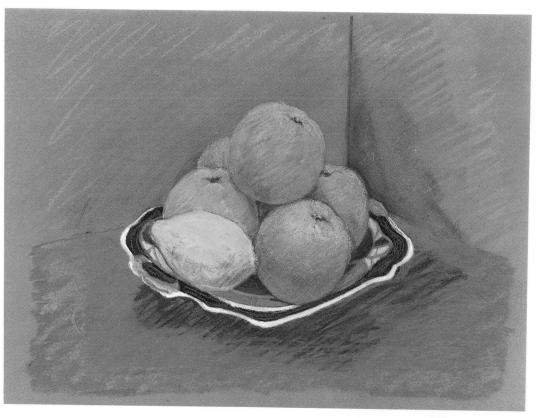

discordant, but the same light mauve will create a vivid sensation against a strong red. A dark orange or red-brown with an intense light blue is generally perceived as a harmonious and pleasing combination. Our sense of harmonies may have to do with the way we associate with the natural world — blue and brown suggest earth and sky, and almost all the imaginable combinations of red and green can be seen in flower and leaf colours. But it is interesting to note that our tolerance of colour combinations has broadened appreciably. Until quite recently there were strong conventions about putting certain colours together, and some pairings were outlawed. Nineteenth-century theories of colour were concerned with "acceptable" colour relationships, but guidelines of this kind have virtually been abandoned.

Colour neutrals If you experiment with putting a square of red paper on a black background and a same-size square of the same red paper on white, you are likely to perceive the red on the white background as having a darker value than it does on the black. Achromatic colours affect the apparent qualities of pure hues and are influenced by them. You may see a greenish tinge in the white where it borders the red square, an effect of complementary contrast. This occurs — but may be more difficult to detect — on the black ground. Just like black or white, neutral greys respond to colour influences.

Many types of grey are not purely neutral, but tend to have a colour bias. There is also a range of "colour neutrals", called tertiary colours, that derive from mixtures of the secondary

ABOVE This small colour test shows how the drawing would have been keyed rather differently if it had been worked on white paper. The orange background, having a vivid presence, requires a bolder approach to the variations of colour in the pastel strokes, but the colour contrast is less stark than on the white ground.

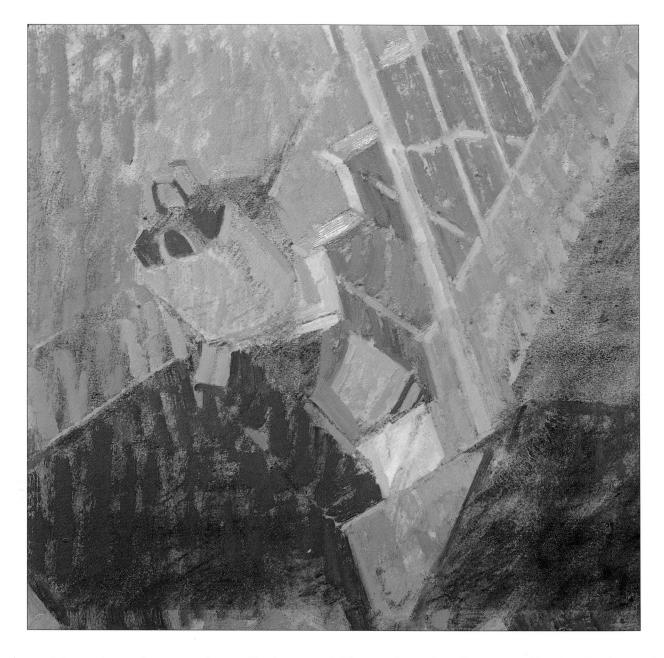

colours. The tertiary colours are the muddy browns, green-greys and pinkish-greys, those that have colour in them but are not as easily definable as the pure hues. Coloured greys and tertiary colours are extremely valuable in pictorial terms, serving to offset the vibrancy of the stronger hues and tones. **Colour temperature** The idea that colours have a perceived effect of warmth or coolness is an often-quoted principle of colour values that can be put to good use in colour composition. Like all other individual and relative qualities in colour interaction, however, it is not so simple as at first appears.

The "warm" colours are said to be those on the red, orange, and yellow side of the colour wheel, and also mixed hues and values with a bias towards red, including redpurples, pinks and mauves. Blues, greens, violets and blue-purples are broadly categorized as "cool" colours. The form of "colour behaviour" attributed to these groups is that warm colours typically advance, while cool colours tend to recede, thereby providing spatial and structural characteristics which can be employed in creating a balance of colour values in a composition.

There are properties of light and colour that relate to this principle, to do with the speed and strength of the light wavelengths and the eye's receptivity to different colours. But it can be demonstrated in purely pictorial terms, and it is worthwhile studying paintings and colour drawings to see how artists have put these colour qualities to use in enhancing compositional elements.

There can be a problem, though, if you depend on the apparent behaviour of warm or cool colours on the basis of a

The Properties of Colour

LEFT Michael Upton's small oil painting shows a strong sense of draughtsmanship in the basic structure of the image and the manipulation of the brushstrokes. The muted tertiary colours have an effective balance of tonal contrasts and colour influence. simple division of the colour wheel, because the relative tonal values of colours and the influences within mixed hues also play a part. Some pale, cool colours will seem to advance quite strongly — such as an icy light blue or cold yellow-green — whereas some reds have a bluish tinge that makes them recede slightly from fiery orange-reds. Once again, this idea of colour temperature has to be evaluated in practice within the context of your given range of colour relationships.

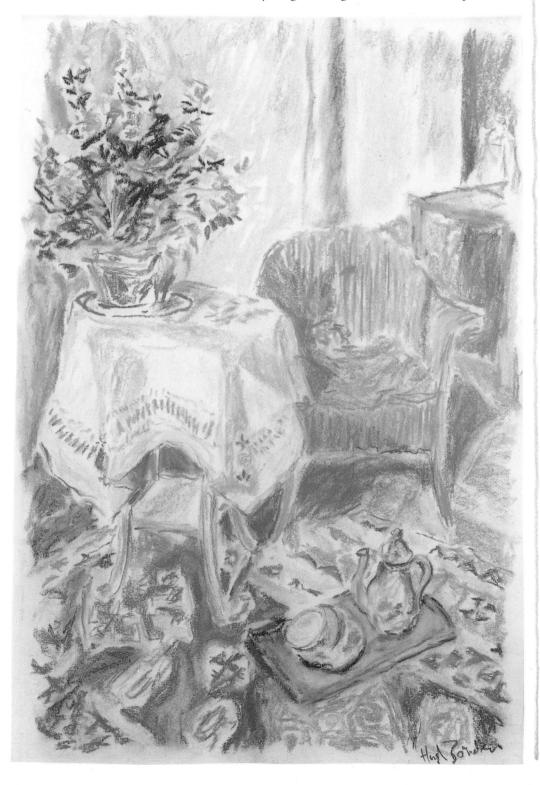

TOP A range of pure hues passing from warm to cool colours shows the variation of effects: yellows, for example, may appear warm and sunny or relatively cold and harsh.

ABOVE Greys and neutrals can show a considerable variation of colour bias.

LEFT Hugh Barnden's interior study creates space with a contrast of warm and cool colour. The recession from rich reds into cold blue and mauve shadows is enlivened by the introduction of acid yellows and greens focused at the centre of the composition.

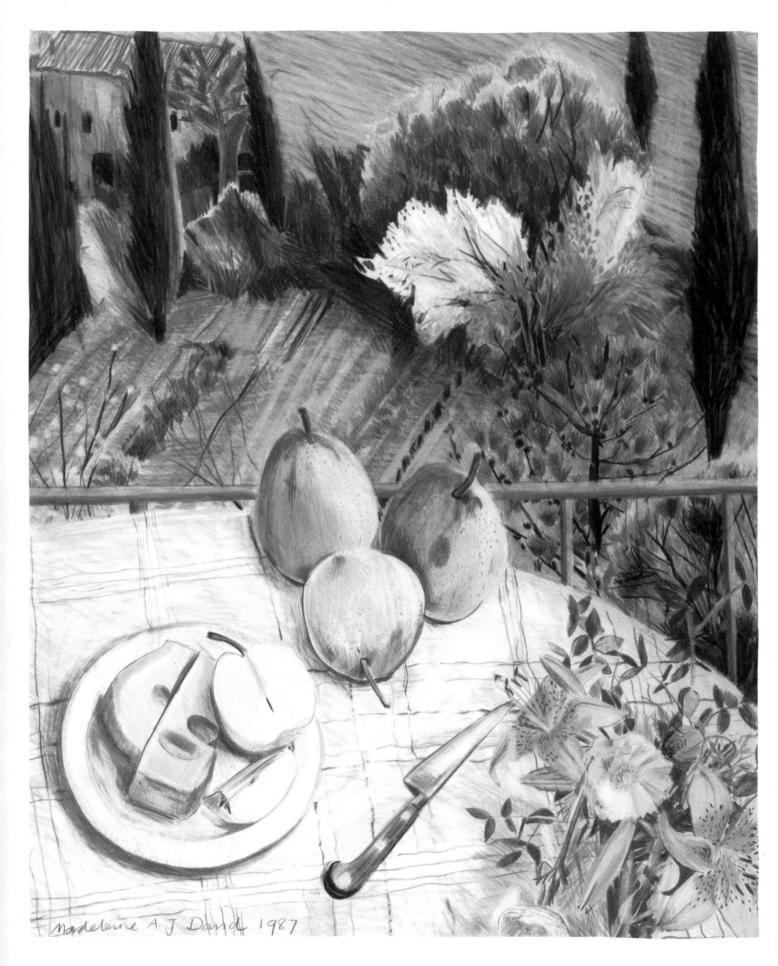

Physical Colour

LEFT A vibrant effect of light is created by the balance of tones in this coloured pencil drawing by Madeleine David. Shading and hatching are used to mix the colours and develop form and texture. The high viewpoint provides an unusual composition. Colour in drawing has a material presence — whatever our sensations of and responses to colours in the real world, the ways in which we express these in drawing are dependent on the qualities of the materials we use. Each type of material provides its own characteristic colour values and surface textures, so the more you know about your materials, the further you can push the boundaries of your drawing skill and make the colours and textures work for you.

This chapter examines the qualities of all your possible sources of colour in drawing, the technical ways of handling them and their comparable effects. But it is worth noting at this stage that colour coding in drawing materials is not standardized, nor does the way a colour appears in stick or pencil form or on the casing of a marker always correspond to the effect it gives when laid on a drawing surface. It is essential to gain practical experience of the materials, especially the results of colour mixing, which can be unexpected. Experiment with the various media, and explore the potential of BELOW A drawing which so successfully creates both solid form and a sense of atmosphere results from the artist allying her technical expertise to a highly developed skill in colour perception. Sally Strand is able to judge the precise combinations of hues and tones that recreate a specific visual impression. The way she handles the soft pastel textures allows every hint and accent of colour to make a telling contribution to the overall image.

ABOVE This exercise explores the effects of different drawing media applied to the same subject. Coloured pencil has a more lightweight, open effect than that of opaque, loose-textured pastel. Overlaid marker colours build a solid sense of form, while pen and ink drawing exploits calligraphic qualities.

ABOVE The clarity or density of soft pastel colour depends on the closeness of the marks and the edge quality of the pastel stick, varying from sharp lines to solid, grainy colour.

different papers — smooth or textured, white or toned, for example. Exercises are useful in this context. Making "test patches" of colour in an abstract way can help to broaden your technique, especially if you have learned a particular way of drawing or find that you habitually approach different problems by the same well-tried routes. Don't, however, treat the information in this chapter as a form of apprenticeship you should work through before thinking of more ambitious projects — drawing is a continual process of learning in which all forms of practice contribute to developing your skills.

THE MEDIA

Pastels Soft pastels are a source of clear, brilliant colour. The quality of the pigment is very little affected by the small amount of binding medium used to contain the powdery colour in stick form. Though individual pastel strokes lay down clean, opaque colour, the gradual build-up of powder on the drawing surface can create a muddy, veiled effect. This cannot be eliminated altogether, but experience in handling pastels teaches you how to maintain the colour values or rework them to retrieve their clarity. Fixatives, which set the loose colour in place, help to control surface effect in work in progress, as well as protecting the finished drawing, and a good-quality fixative should not cause any change in the drawing's colours and textures.

Medium and hard pastels contain more binding medium than soft ones, and are relatively more stable, but they do also develop a film of loose colour and remain liable to smudging. When you work with pastel your fingers quickly become coated with colour, and for this reason some types of pastel are paper-cased, and others protected with a fine plasticized coating for easier handling. Pastel pencils, in which the thin sticks of colour are encased in wood, are cleaner to handle, but less versatile. You cannot use them to lay in broad areas of colour, as you can by using the side of the pastel stick, nor can RIGHT Judith Rothchild's atmospheric drawing demonstrates the degree of detail that can be achieved with expert handling of pastels. The bright accents of colour in the red flowers and the dappled background light are effectively played against the dark tonal register of the shadowy trees.

ABOVE Pastel pencil is clean to use and gives a relatively even line quality as compared to thicker pastel sticks, although the linear texture can also be worked in hatched, stippled or scribbled marks to create densely knitted colour effects.

Drawing With Colour

RIGHT A colourful image can be achieved using only line work and a limited colour range, as in this pen and ink drawing of anemones.

RIGHT Nicely regimented lines of vegetables have a vigorous character due to the freely worked texture of the coloured pencil drawing in which Madeleine David has used an inventive approach to building the colour mixtures. The yellows and browns in the onions are worked over soft purple shading, with strong white highlights overlaid to simulate the shiny skins. Dark-toned blues give extra brightness to the natural yellow-greens of the leeks.

BELOW Wax crayons have a slightly more subtle effect than oil pastels. Although handled in similar ways, it may take longer to build the strength of the colour values.

BELOW Oil pastel colours have a particular vibrancy because of the waxy medium used to bind the pigments. Like soft pastels they make characteristically grainy marks, but with overworking the colours readily fuse together.

you make the particular sharp line quality that the section edge of a round or square pastel stick creates.

High-quality artists' pastels are produced in tints (pale tones) and shades (dark tones) of a wide range of pure hues to facilitate tonal gradations and colour blends. Boxed pastel sets offer selected colours, some representing a basic "palette" for colour mixing and others representing colour families — a range of reds or greens or a particular combination of colours such as greens, blues and browns for rendering landscape.

Oil pastels The binding agent — a mixture of wax and fat in oil pastels gives the colour sticks a greasy texture. Broadly speaking, this is a cruder medium than soft pastels, and the colour range is relatively limited. Oil pastels do not crumble into powder, so they are in some respects easier to control, but they can produce an unpleasantly smeared effect if handled carelessly. A thick application of oil pastel produces a solid layer of colour that can be used to draw "negatively", by scraping back the colour. The waxy texture is also useful for resist techniques (see page 129).

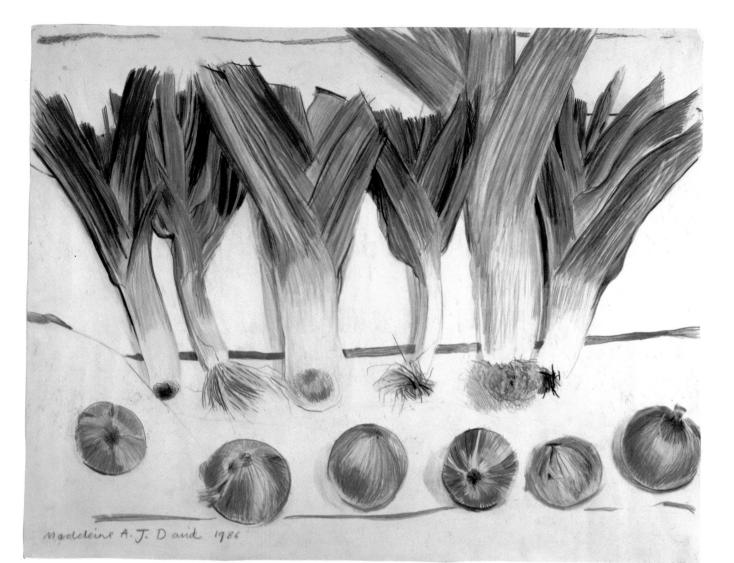

Crayons The term is often applied to coloured pencils, but should refer to solid sticks of colour, similar in appearance to pastels but often supplied with one end fashioned to a rounded point. The binding medium is typically a waxy or oily substance. Inexpensive coloured crayons of the type used by children can be rather harsh and unsubtle, but there are also better-quality types suitable for artists' use. The slight translucency of the binding medium gives the colours a surface clarity. Crayons, like oil pastels, are particularly useful for resist drawing methods.

Coloured pencils The shape and texture of coloured pencils —thin sticks of bound pigments encased in wood — provide a finer and more essentially linear drawing quality than pastels or crayons. Different types vary in the texture of the coloured "lead". Some have hard, relatively brittle leads, that can be shaped into long, sharp points for very precise line work, while others are naturally soft and crumbly, more manageable than pastels but characteristically producing a broader, more grainy line than the hard pencils. The differences are caused by

RIGHT The fineness of coloured pencil provides considerable versatility in working up hatched and shaded textures. Despite the linearity of the medium, it can be used to achieve solid blocks of colour or subtly graduated tones.

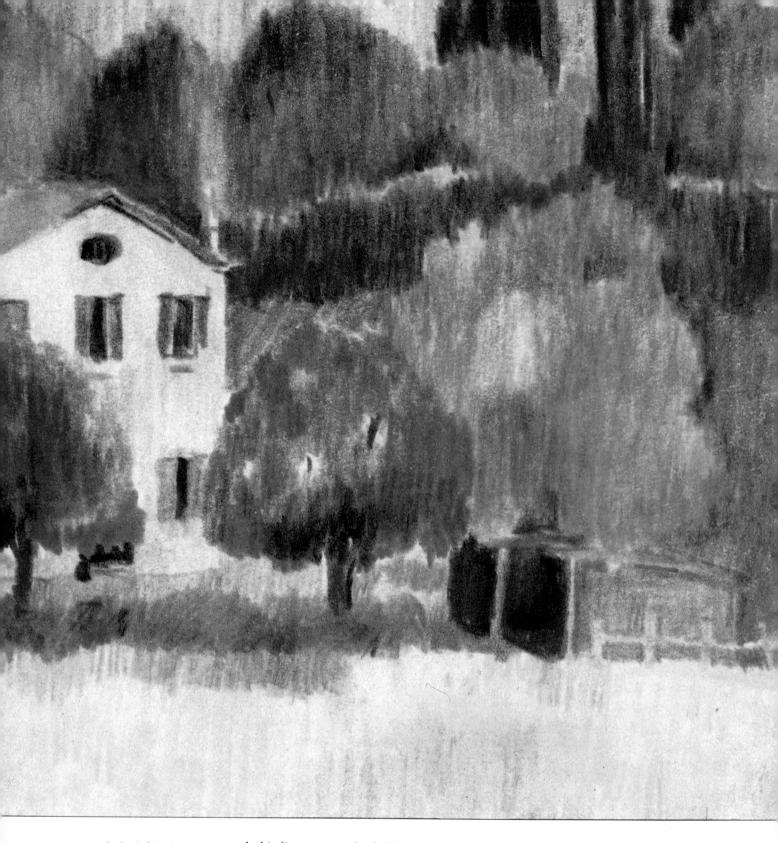

ABOVE This detail of a landscape drawing by Moira Clinch shows how soft coloured pencils have been used to create layered marks woven into mixed hues and tones. Working the pencil marks in one direction, in this case vertically, gives the overall image a cohesive surface. the binding agent used to hold the pigments. You can see and feel differences of texture if you look closely at the range of coloured pencils in a display stand, but you will only know the precise drawing quality when you start to work with them.

Coloured pencils characteristically produce a translucent effect that allows you to layer colour marks to produce mixed hues and tones. Individual ranges may provide more than 60 colours. You can choose whether to maintain the same textural quality by using a single type in a drawing, or to take

Physical Colour

advantage of the range of textures by mixing different brands. You will probably need to use fixative to stabilize the drawing surface, either while the work is in progress or when the drawing is completed, especially if you use the softer types.

Some manufacturers produce water-soluble coloured pencils that can be used either dry or wet. When you have laid the colour on paper, it can be spread using a soft brush wetted with clean water. This enables you to produce effects of line and wash with the single medium. You can also dip the pencil point in water and twist and turn it on the paper to make vivid calligraphic marks.

Markers and felt-tip pens Markers have recently become an extremely important medium for certain types of colour rendering, particularly in the areas of design and graphic presentation. They are quick, convenient, and available in a wide range of coordinated colours, enabling artists to rapidly produce quite detailed and impressive colour visuals that would take hours to do with paint. The drawback is the unpredictable lifespan of marker colours, as they change and fade on prolonged exposure to natural light. All artists' media are slightly variable from one pigment to another, but for practical purposes they are relatively stable, whereas some types of marker or felt-tip pen colours degrade quite quickly.

One solution is to use these media in combination with others, and to apply fixative, which slows the degradation of colour values. They are certainly extremely useful tools for sketching and working drawings, being a source of varied and fluid colour that is also easily portable and does not require use BELOW Markers are excellent for quick sketches giving a vivid impression of form and colour which can later be developed through more detailed drawings. Overlaying the transparent colours creates a sense of depth and the movement of the pen tip contributes a vigorous quality to the subject even when, as here, it is rendered only as simple colour blocks.

Drawing With Colour

RIGHT The fine lines made by felt-tip pens give sketches a character distinctly different from that of marker work, though the colours have a similar boldness. Here hatching and shading have been used to develop an interesting "colour notebook" of landscape impressions.

ABOVE The transparency of felt-tip or marker ink provides a direct method of colour mixing. It is useful to make a colour chart of the various effects for future reference.

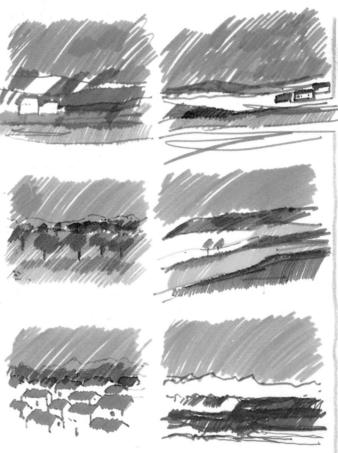

of a diluent or solvent. In these contexts permanence is not essential. Keeping examples of your sketches and colour roughs over a period of time also provides a way of monitoring the relative stability of the colours.

Felt-tip pens and markers may have pointed or wedgeshaped nibs, either broad or fine, and may contain watersoluble or spirit-based ink. Spirit-based inks tend to spread, "bleeding" into the paper surface beyond the passage of the nib, so you need to make allowance for this if you want to work within fairly precise shapes. When working on a sketch pad, you may also find that the colours bleed through onto the next page, but you can obtain special marker pads in which the paper is formulated to resist colour bleeding.

Drawing inks These are a useful medium because you can use either pens of various types or brushes to make a variety of different marks. The colour range is limited, incorporating, for example, two different values of red, yellow, blue and green with orange and purple, brown, sepia, black, white, and gold and silver inks for decorative effects. Some drawing inks dry to a waterproof finish allowing you to build a good depth of colour density by overlaying linear marks or washes of colour. Water-soluble inks, including products described as "liquid watercolours", offer a range of concentrated colours that can be diluted with water but are not fully waterproof when dry.

ABOVE Pens and drawing inks are now rather neglected in favour of the convenience of markers, but metal pen nibs can be manipulated in ways that add rich textural detail to an ink drawing through variations of line and tone.

ABOVE Watercolour washes are not only suited to broad expanses of atmospheric colour. With strong hues and varied brushstrokes, watercolour can also convey a calligraphic energy. You can obtain dip pens with interchangeable nibs that provide you with a range of linear options, from very fine to very broad. But you can actually use any stick-like implement to draw with coloured ink, so it is possible to experiment with loose and textured marks. Any of the paint brushes recommended for watercolour and acrylic work are suitable for ink drawing, but waterproof inks contain shellac or a similar drying medium that can clog brushes and pens; so be sure to clean your drawing tools thoroughly. And never use waterproof ink in a closed-reservoir pen such as a technical pen or fountain pen.

Paint Any type of artists' paint can be used for drawing, and any technique of applying it. There is no particular advantage, however, in using oil paint: it is slow drying and requires special diluents and solvents. It is also necessary to prepare a ground of gesso or emulsion to work on, as oil mediums BELOW A highly active black ink line is elaborated with watercolour washes in a drawing by Ian Ribbons of a biker in full leather regalia. Black is used not only to provide a structural framework but also as a positive element of local colour in the details of the bike and clothing.

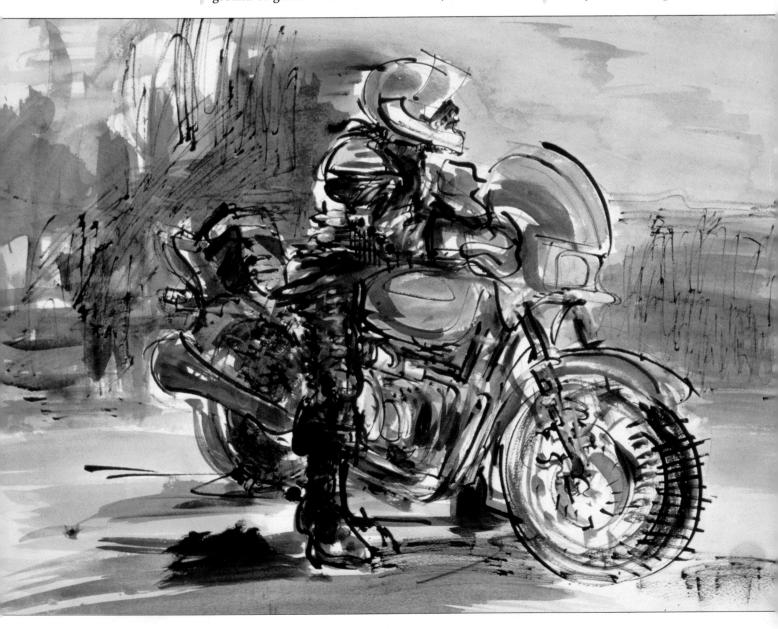

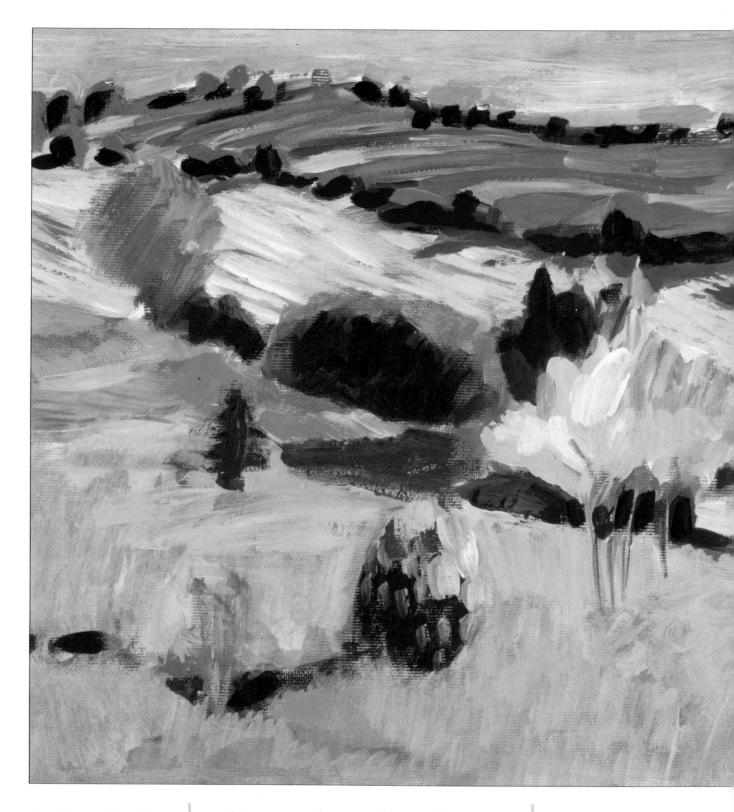

ABOVE The crossover between drawing and painting techniques is demonstrated in this acrylic landscape by Jane Strother, in which every brushmark counts towards building the impressions of space, form and texture. spread into untreated paper and eventually cause it to deteriorate. Watercolour, gouache and acrylic paints are all quite suitable for use on paper. They are also convenient, as you only need water to dilute the paint and to clean your brushes. They can also be used in combination with the "dry" linear drawing media to create complex effects of colour and texture. Acrylic and watercolour washes provide transparent

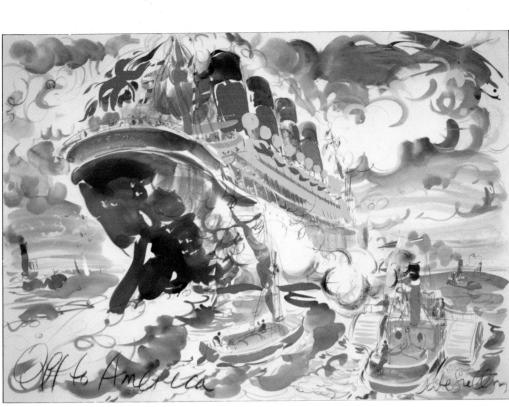

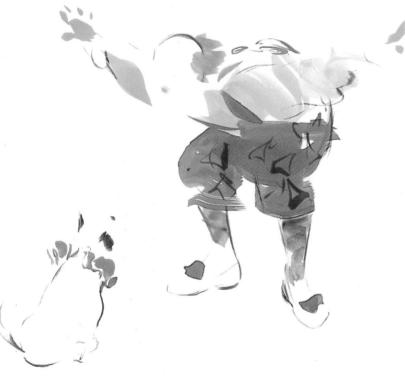

RIGHT With fluid confidence, Jake Sutton's bright watercolour sketch captioned "Everyone can fly" — precisely captures an engaging moment of interaction between clown and dog. colour values that work well with coloured pencil and crayon drawing, while opaque gouache dries with a surface quality similar to the density and colour brilliance of pastel.

COLOUR MIXING

Including mixed colours in a drawing tends to produce a greater depth and variety in the finished image than does

TOP Jake Sutton's exuberant brushwork and clear primary colours create a vivid celebratory atmosphere, very far from the restrained character traditionally associated with the medium of watercolour.

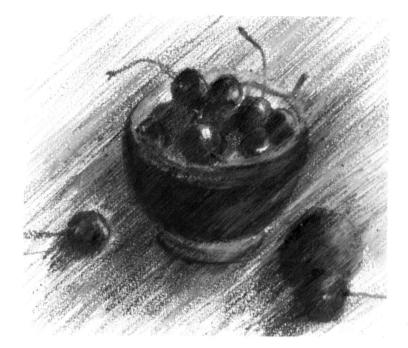

simple reliance on the manufactured colours of individual materials. Mixed hues and tones are mainly created by layering or interweaving coloured marks to build variations in the colour values. The disadvantage of colour drawing as compared to painting, where colours are mixed independently in a palette, is that it takes longer to discover whether the effects of the more complex colour mixtures are the ones you expected or wanted.

An advantage is that coloured drawing materials are relatively inexpensive, and as you increase your stock you have a great many colours to choose from. Also, because you will often be working gradually towards a finished image, you will have plenty of time to make adjustments to the colours you have already laid down by introducing new elements. As you develop the colour qualities on the paper surface, you can make subtle and intricate combinations, either across the whole area of the drawing or in key passages that enhance the overall effect of existing colour values.

There is no need to feel confined by working with basically linear media, as there are many ways to blend and layer the drawn marks to produce rich effects of colour and texture. The variations in technique depend on four main factors: the texture of the material, the quality of the point or edge of the drawing tool, the angle at which it is held and the range of gestural movements you employ. The tone and texture of the paper are also important elements, affecting the surface qualities of the colour work.

There are no fixed formulas for colour mixing in drawing; it is a matter of trial and error, of becoming accustomed to each medium and understanding how its inherent colour values can best be combined. You can experiment with the different ABOVE Jan McKenzie builds the rich colour effects of her drawings by mixing the media freely. The colours of the cherries were first established with a base of watercolour, over which oil pastels and coloured pencils were worked together to develop the range of hues and tones. The technique of dense hatching creates the colour mixtures. The direction of the pencil and pastel strokes is consistent throughout, although this is less apparent in the bowl and cherries where the colours have merged more solidly than in the open background texture. The lush effect of the fruits is enhanced by the opaque white highlights, a finishing touch which further enlivens the darker hues

values that can be obtained by working light colours over dark or vice versa, combining three or four colours to make a complex mixed hue or dark tone, varying the density and direction of the marks to alter the surface effects and so on. Investigate also how easy it is to overwork a correction successfully and how you can draw with the eraser to make "negative" effects, which further vary the colour values and surface texture. Testing the purely physical qualities of colour mixtures gives you a reservoir of knowledge which you can subsequently apply to specific goals in drawing. Technical practice also gives you more confidence in carrying out projects — it can take a while before the elements that you put into a drawing start to come together, and you need to keep a positive sense of what you are aiming for until the magic moment when the image really comes alive.

Shading and blending In this context, shading is taken to mean creating colour values in terms of mass, the final result being a dense and relatively even colour area. Subtle blends, mixed hues and graded tones are produced by overlaying shaded blocks of different colours. These can be made hard-edged to create abrupt transitions defining space and form, or softly integrated one into another to develop a more gentle description of volume or an atmospheric sense of space and distance.

Shading with a dry-textured and basically linear medium such as coloured pencil, pastel or crayon tends to produce a grainy effect. The degree of graininess depends upon the quality of the medium itself, the texture of the paper and the amount of pressure you use to lay the colour — heavy pressure forces colour into the paper grain. If you start out by applying a densely compacted colour layer, you will reduce the range of

ABOVE Oil pastel and coloured pencils are combined in a series of individual studies of fruits by Jan McKenzie. Here she has created a lively variation in the direction and texture of the marks. The apple shows a hint of watercolour work in the pale pinks and yellows underlying the coloured pencil strokes, but in this and the other fruits, the density of colour is built up more by cross-hatching with the coloured pencils and stippling with pastels. Clever judgement of the exact tones and locations of the highlights again emphasizes the surface texture, also helping to model the forms.

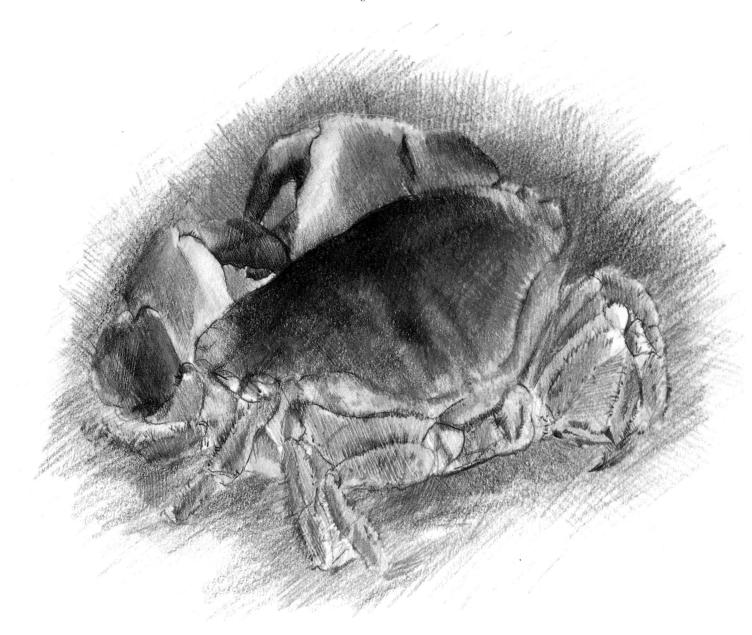

ABOVE In this convincingly detailed colour rendering, the almost solid colour areas in the background and the crab shell are mainly developed through hatching and cross-hatching. In some areas, oil pastel has been scratched through with the point of a lightcoloured pencil to lift the tonal values. Jan McKenzie combines not only two separate media, but also different types of coloured pencils, with hard and soft leads, to achieve the required effects of colour and texture. possibilities for developing mixtures. This is especially the case with wax crayon or oil pastel, when the fatty quality of the binder creates a resistant surface. Some coloured pencils also leave a waxy finish.

The slightly broken effect of lightweight shading, which naturally occurs as the point or edge of the medium passes over the paper texture, allows successive colour applications to build mixed hues and tones through integrated colour layers. Different weights and emphases can also be created across a colour area by varying the direction of the shading in separate colour applications.

Coloured pencil is characteristically a more transparent medium than pastel. Subtle and delicate effects are possible because movements of the pencil point can be finely controlled and colours maintain their clarity as the layers are overlaid. Opaque pastel is a bolder, looser medium. The texture can be

Physical Colour

exploited in blending the loose colours on the surface by rubbing with your fingers, a paper stump or a cotton bud. If you over-mix you will devalue the colour qualities so it may be necessary to use fixative frequently to seal each colour layer before working over it. Alternatively, it might be more appropriate to use one of the open, linear techniques of colour mixing described below, but the character of the drawing must be taken into account.

Blending marker colours Felt-tip pens and markers naturally produce a different result because they lay wet ink that floods the surface, following the path of the felt tip. Mixtures occur because the ink is transparent, so each succeeding colour layer modifies the hue or tone of the one before. Marker ink dries quickly, however, and you tend to get a streaky, lined effect in a block of colour, the texture varying according to the width of the nib and whether it is pointed or wedge-shaped. The directional strokes given by markers are often exploited to emphasize form and contour, but you can obtain a smoother effect if you wish, by working quickly and running each pass of the nib into a preceding wet edge of colour. Colour gradations are made either by overworking with the same hue to darken the tones where required or by introducing a different colour - for example, running red-brown over a bright mid-toned red. Because the ink is transparent, pale colours make little impact on darker ones so you need to plan the colour sequence to obtain the right effect of light-dark gradations.

Colour wash Transparent washes of diluted ink or watercolour are traditionally associated with drawing, for example, as a means of introducing colour and tone to line work in pencil or pen and ink. In colour drawing, washed areas laid layer upon layer with a soft brush can be used as a primary method of building form, but washes also combine well with the linear drawing methods of creating colour mixtures. These could be coloured-pencil hatching or stippling, or scribble-textured marker work, or intricate pen drawing using coloured inks. The soft, fluid character of a colour wash provides an effective background tone for a drawing or can be used to create soft veils of colour over parts of a drawing to alter the focus and clarity in selected passages. If you intend to apply washes over previously drawn work, check first that none of the drawing media you have used is water-soluble, otherwise you will lose the definition in the drawing.

Hatching This is one of the most commonly used methods of creating blocks of colour and tone in drawing. Hatching consists simply of roughly parallel lines drawn with a pointed or edged tool. By varying the thickness of the lines and the spaces between them, you can make an optical effect of different degrees of tone. When two or more colours are

ABOVE The only way to get to know both the textures and colour qualities of your materials is to try them out, working in different ways to discover the typical marks and ways of mixing and blending the colours to create a range of effects. The purpose of this exercise is to become familiar with handling a particular medium, or combination of media, not to aim for a finished image, and it is useful to allow yourself a free approach. In these oil pastel sketches, the subject simply forms the basis for investigating surface effects and a changing balance of tone and colour.

ABOVE Tom Robb works with felt-tip pens to create a faceted landscape of hatched colour blocks. The directional marks knit together the different elements of the image and the colour gradation is closely integrated to make an easy transition through the space of the landscape. The strong touches of red provide a focal point in the middle ground.

hatched together, the hues and tones seem to merge into a complex mass of colour values.

Hatching can be very neat and precise, or very loose and emphatic. It has a directional emphasis according to how you form the strokes, and this can be manipulated to create the effect of changing planes and curves in describing solid form. Cross-hatching is the process of overworking an area with lines angled across the previous direction of the hatching. This builds a more densely woven textural effect that can be varied by spacing the lines openly or close together and varying the angle of their crossing. LEFT In a painted study by Judy Martin, the brushwork is contrived to imitate a linear drawing technique. Opaque gouache allows light colours to be layered over dark, as where the light blue sky tones "showing through" the greens are actually the final layer scribbled in with the tip of the brush.

RIGHT Moira Clinch's domestic interior investigates the vibrancy of colour that can be found in familiar scenes. It combines a strong sense of pattern with an effect of powerful illumination. The colours are meshed together through a series of individual marks dabbed and stippled across the surface, mixing into varied textures and patterns.

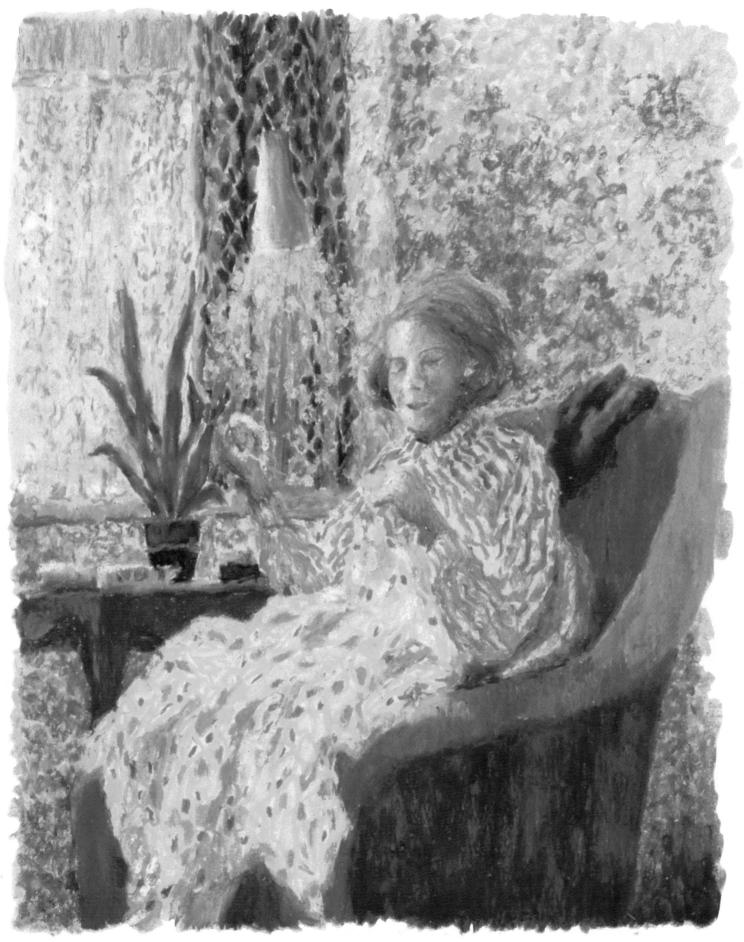

Dots, dashes and scribbles Any mark that you can make with a drawing tool can become a component of a colour area. The effect of masses of marks of different colours is to form the appearance of mixed colours — this is known as optical mixing. Close to, you can still see the component colours, but from a distance they seem to merge.

A traditional method of creating an optical mix is stippling, fine dots of colour built up to create the effect of mass. Any of your drawing media can be used in this way, and the control you have over these small marks provides a way of creating very precise form and complex colour values. Other types of marks can be used on a similar principle to create colour mixing — the more vigorous you make the calligraphic quality of the marks, the more energy and textural variation you obtain in the drawing surface. You can use dashes, ticks, squiggles or arabesques of colour and make them mix and blend in different ways by controlling the amount of each colour in a given area and the size and spacing of the marks.

Open scribbling works in a similar way to hatching, but is a more fluid process since you do not lift the drawing tool in

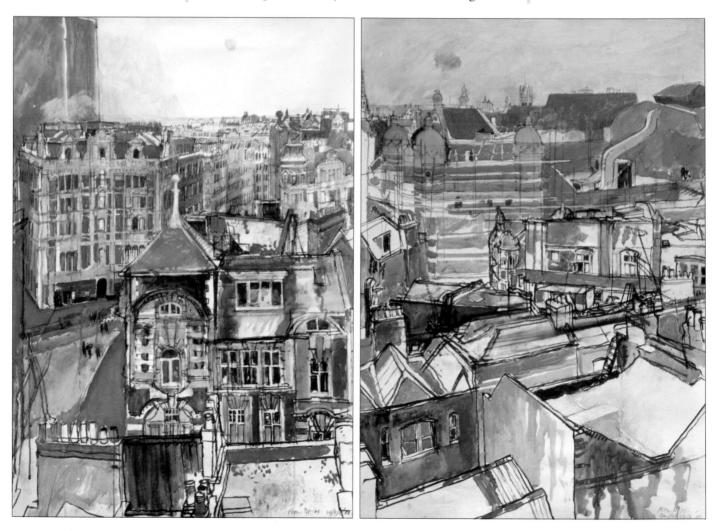

BELOW Two complex "bird's-eye" view townscapes by Ian Simpson, which combine to form a continuous image, depend on a strong graphic framework of ink and pencil line drawing. Within this structure, colour washes are applied as representational colour describing roofs, walls, chimneys, and the street below, enhancing the sense of place and time. Loose brushwork adds to the detail of the images, suggesting a range of surface qualities.

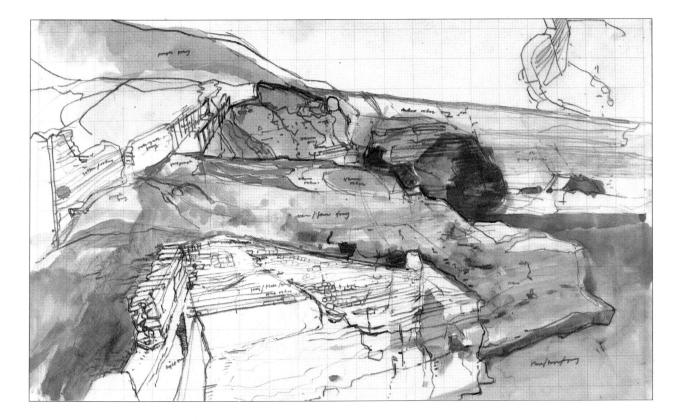

making the lines, and they remain loosely connected. The method enables you to exploit the sense of movement in the drawn lines to express rhythms and tensions. The gestural quality of the marks depends on the movement of the line and the scale in which it is incorporated. You can make quite vigorous gestures of hand and arm when working on a large scale and in the final drawing surface the marks may register as a relatively controlled element, whereas in a smaller-scale drawing the same gesture would be dominant and difficult to integrate within the overall sense of space and form.

Coloured papers You can draw on or draw with coloured paper — either way it is a positive factor in colour drawing. Often you will find the brilliance of white paper particularly useful in allowing your drawn marks to activate the surface most colourfully, but you might sometimes choose to work on a tinted or even quite strongly coloured ground.

Coloured papers are most commonly used for pastel drawing. The neutral grey or bufftones are useful for setting a tonal key in the light to mid-toned range, while blues or browns can provide a basic "colour temperature", cool or warm respectively. The range known as Ingres papers, much used for pastel work, includes various tones and colours, some very pale, others dark-toned, a few quite strong in colour. Some high-quality watercolour papers are also available in colour tints.

Because pastel colours are opaque, they can be used to cover up the paper surface completely, but if you use grainy ABOVE Watercolour sketches have traditionally served as artists' reference, providing rapid colour notation later used as the basis of more detailed "finished" paintings. As proved by this landscape drawing by Ian Simpson, such sketches have their own considerable vigour and charm. Colour washes are applied over blue and black ink line, and the artist has also included written notes on the colour accents and subtle undertones. These elements could later be introduced into a more fully worked version of the view, enlivening the basic variations of local colour recorded in the original watercolour sketch.

ABOVE The combination of dry drawing media with fluid colour can be exploited to increase the range of texture within an image. This is a simple colour exercise testing the effects of combining oil pastel with marker ink and watercolour. The greasy surface of the pastel repels the ink or paint, allowing the scribbled marks to show clearly through the overlaid colour strokes.

RIGHT Jane Strother shows confident control of a mixed media approach, combining torn pieces of coloured paper with pastel and watercolour to develop a vivid, freely described still life. The paper pieces dictate a strong colour key, but are matched by a well-judged tonal balance in the drawn and painted elements. The translucent tissue paper provides sofiedged colour blocks over which fluid brush lines and grainy pastel textures are used to draw in the still-life subjects. The white space surrounding the paper pieces has an important positive presence within the image. shading or open calligraphic marks, the tint of the paper shows through and contributes to the colour key. Brush drawing with an opaque paint such as gouache or acrylic works in a similar way. A more transparent medium such as ink or coloured pencil is obviously more significantly affected by paper colour, which modifies the overall effect of the applied colours.

Coloured papers have a natural affinity with coloured drawing media, and the positive colour contribution they make gives a unifying effect that is not supplied by white paper. You can select the paper colour according to whether you want it to stand as highlight or shadow, provide accents of colour or act as a flat background tone.

As well as the neutral and subtly tinted pastel papers, there is a wide range of bright-coloured cartridge and other relatively smooth-textured drawing papers. A strongly coloured ground can be too harsh and dominating for certain types of drawing technique and some kinds of subject matter, but there is no reason why you should not experiment with vivid colour in your drawing paper, especially if your medium has enough colour strength and opacity to hold its own. A problem with all coloured papers is that they vary in their permanence. Some will gradually fade on continuous exposure to light and the effect of this colour loss is not predictable.

If you are unable to find the right coloured paper for quieter background tones, you can create them to order, either by covering white paper with a watercolour or ink wash or by crumbling a pastel stick into powder and rubbing the colour into the paper surface, using your fingers, a rag or a ball of cotton wool. This is a way of obtaining a reliably permanent coloured ground. If you use a wet medium, make sure that it is completely dry before you start work with a pointed or edged drawing medium, otherwise the pressure you apply will cause damage to the paper.

Paper collage The vigorous collages of Henri Matisse's later years are a wonderful advertisement for coloured paper as a drawing medium. You can create fascinating images by arranging torn and cut paper pieces, exploiting the edge qualities and colour values of different types of paper. Collage can also provide a good basis for single- or mixed-media work — pastel, ink, coloured pencil. In the same way that a whole sheet of paper provides an appropriately coloured ground for drawing, paper pieces can be stuck down to form the basic planes of an interior, a landscape or townscape view, for example, or the silhouette of a figure, and you can then start to develop the detail by drawing over the collage.

Physical Colour

Collaged townscapes

A simple structure of colour blocks can be quickly achieved with collaged paper as the basis for any style or technique of drawing. This could be done by blocking in colour on white paper with a suitable drawing material, but the collage method is sometimes more suitable for particular images, such as these townscape views. The coloured paper provides solid blocks of flat colour, unlike watercolour or ink washes, for example, which would have a textured effect. Using paper saves time as compared to shading with coloured pencil or crayon, and avoids the risk of forming a compacted surface texture which might become resistant to further work in the same or other drawing media.

For the first study (right), a coloured pencil sketch was first made to establish the form of the composition. A simple collage based on the local colours in the view was constructed from the sketch. Line drawing in coloured inks was used to develop the character of the image, with some coloured pencil work in the final stages to touch up the collage.

In the second example (far right), a rapid sketch was again the preparation for the full drawing. Collage was applied to form the warm brown tone of the foreground and the block shapes of some of the buildings. The colour relationships and structural detail were then worked over the collage. in pastel and gouache.

Physical Colour

Descriptive Colour

LEFT A drawing is descriptive both in representing what the artist sees in the subject and in the way the materials are handled to achieve the visual impression. Jane Strother's coloured pencil drawing conveys the essential details of the still life while at the same time exploiting the surface qualities characteristic of her materials. Colour is often the feature of a subject that makes us want to create a picture of what we see. The fresh greens of a summer landscape, the brilliant hues of autumn trees, the vivid artificial colour in fabrics, ceramics and other manufactured objects, or the glowing natural coloration of fruits, vegetables and plants make a direct appeal to the eye. Just as enticing are the subtle shifts of colour that can occur with equal delicacy in a seascape or in the flesh tints of the human body, and the bright accents in an interior or townscape view. Colour drawings can, as much as paintings, capture the beauty and variety of these innumerable visual attractions that surround us.

This chapter investigates the concept of representational drawing with colour and explains the processes which enable you to re-create your own impression of a selected subject. The key to descriptive colour rendering lies less in drawing technique than in the visual skill of keen perception — in simple terms you need to look hard, and look again, before making any marks on your piece of paper. Once you can really

BELOW A strong contrast of tonal values and the rough texture of wax resist recreate a powerfully descriptive view of a rocky outcrop overlooking an industrial town in this drawing by Julian Trevelyan. The smoky-toned watercolour washes are vigorously scrubbed across the wax drawing, producing a rugged image evocative of the landscape.

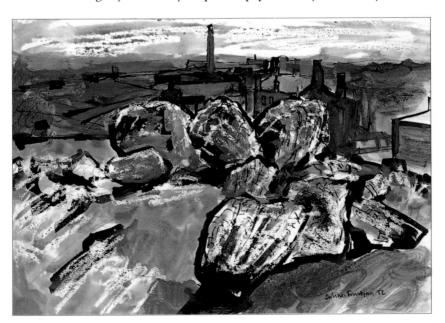

see what it is you want to draw, you are better equipped to find the right technical means of doing so. Much of the information in this chapter relates to methods of visual analysis that can help you to organize your drawing effectively.

But technical skill is important too, especially as the different drawing media can contribute a wide range of colour values and surface textures that leave their own impression on the final quality of the image. Improved perception and technique both develop naturally through the practice of drawing, "practice" meaning that you make drawing one of your regular activities and are prepared to work and re-work a particular problem until you achieve a satisfactory solution.

Any attempt to make a colour rendering based on detailed and observant study does require discipline on the part of the artist. It should be viewed as serious work — but that doesn't mean you can't enjoy it. If you want to produce the kind of drawing that represents the subject reasonably accurately, you may find the challenge stimulating and absorbing. But if you find this close attention to the details of the real world more of a chore than a pleasure, this could mean that you will find other ways of interpreting a subject through drawing, as explored in later chapters, more rewarding.

THINKING IN COLOUR

When you draw in monochrome, with graphite pencil or charcoal, the medium naturally prescribes which elements of the subject you can successfully convey. Because you are not using colour, it is easier to focus on qualities of contour, mass and texture, qualities that can be described effectively with a medium of line and tone. The process of learning to view a subject selectively, to analyse and interpret its essential forms, is an important experience that can be gained through drawing, and is at least one of the reasons why drawing is often thought of as a preliminary to painting rather than as a self-contained method of developing finished images. The traditional relationship between drawing and painting encourages artists first to separate form and colour, then to put them back together.

Drawing directly with colour requires a different kind of approach, because you must regard colour from the start as one of the major compositional elements, influencing both your choice of subject and your arrangement of it into a pictorial image. This does not mean you should ignore the other main ingredients of two-dimensional composition outline and contour, mass and volume, light and shade, pattern and texture — but it is necessary to think in colour from the beginning because the colour relationships will significantly affect the character of the composition. The aim of the drawing exercises and finished examples on the follow-

ABOVE A composition which allows the visual elements to bleed out of the picture "frame" on all sides has the effect of drawing the viewer into the image. In Ian Simpson's coloured pencil drawing of tomato plants, this creates an ambiguous sense of scale which, together with the rich colour density, conveys a jungle-like atmosphere.

ABOVE There is a delicate balance between line and mass in this still life by Jan McKenzie, and a good balance between the cold blue and warm orange hues. The symmetry of the central subject is offset by the arrangement of pattern detail in the background.

ing pages is to demonstrate the principle of "keeping colour in the picture" throughout the process of planning and executing a drawing.

Whether your subject is a still-life grouping, a figure or a landscape, a singly focused or composite image, each real object or view that you are looking at presents a mass of visual information — basic forms, spatial relationships, colour details, effects of light and shade. The fluid medium of paint allows you to manipulate these elements to some extent as you work, but with the slower processes of drawing this is less easy: you need to develop a reasonably systematic approach

Drawing With Colour

that will provide the right foundations for the overall composition and enable you to build up gradually to the more complex stages. The activity of drawing is a process of adding up the pictorial elements and technical effects to arrive at the finished values of the image.

What you need to do is to find a way of breaking down the different elements that you see in the subject, so that you can appreciate their separate contributions to the image. This must be done, however, by some means that maintains the essential colour values in each area of the drawing and keeps in view the colour relationships as a whole, since your materials can express these qualities directly. The exercises and projects that follow are designed to enable you to study the major elements of composition individually, but using methods that involve direct application of colour. Always try to avoid thinking in terms of "colouring in" a drawing that might otherwise be monochrome — go for a clear vision of colour values at every stage.

PLANNING THE COMPOSITION

In drawing you have two main factors under your control: the viewpoint you choose and the materials you decide to use. If, as we are assuming in this chapter, the main aim of your drawing is to record what you see, this places certain limits on the expressive or interpretive qualities of your drawing. For

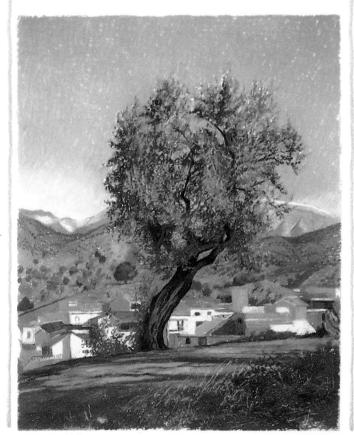

LEFT In her pastel drawing of an olive tree set against the landscape of Malaga, Judith Rothchild places the tree at the centre of the composition but, rather than appearing to divide the image, the curved trunk and branching crown form a sinuous link between landscape and sky. The colours and tones are carefully judged to capture the character of the landscape, the detail of natural and architectural forms, and the brilliant sunlight illuminating the view. This is achieved by the complete integration of patterns of light and shade across the local colours of the landscape.

ABOVE This bright still life by Ellen Gilbert is a lithographic print, not a oneoff drawing, but lithography is a medium in which the artist's drawing technique is directly represented in the final image. Overprinted colours create effects of colour mixing similar to those achieved by overlaying ink or watercolour washes. An interesting element of the composition is the way in which the flowers, which form a vivid focal point, have been described as negative shapes: that is, the white petals show the white of the paper and the contours are achieved by the way the clear yellow is laid in around the flower shapes.

example, if you are working on a still life of objects standing against a blue background, you would not suddenly decide to change the background colour in the drawing to red because you feel it might make a better picture. This would completely alter the relative colour values and pictorial mood of the image which, although a valid approach to drawing, is inappropriate to a representational image. If you are using the subject as a direct model for a colour drawing, it is up to you to decide beforehand whether a blue or red background will create the best effect.

A still life provides you with a wide range of choices which include the general forms and colours of the setting as well as those of the objects used to assemble the arrangement. The same applies to a posed figure. The model can be positioned in a particular place to be framed by, say, a window, a mirror or a flatly coloured wall; furniture, draperies and props such as plants or ornaments can be introduced to vary the shapes, colours and patterns within the overall design, and you can arrive at a pleasing composition before you start to draw.

In a landscape or townscape view, there are fewer ways of manipulating the combination of elements, and in any case, it is the actuality of what you see that attracts you to the subject in the first place. Here your methods of controlling the composition and "setting up the image" are limited to the scale of the drawing, the part of the view you select to draw, and the

ABOVE The artist investigates an alternative way of rendering his impression. In this vigorously expressive sketch, the linear pattern of the composition is explored with paint squeezed directly from the tube.

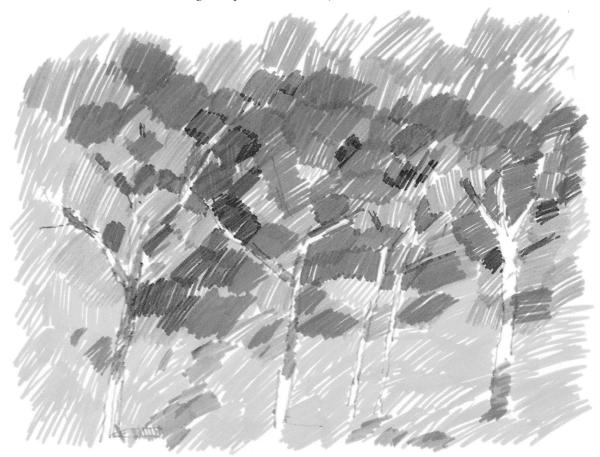

BELOW Tom Robb's quick felt-tip pen sketch captures a distinct sense of place and the dazzling colour effects that have attracted him to the subject. The composition balances strong vertical and horizontal stresses. viewpoint from which you observe it. You have to find the particular viewpoint from which the subject is seen at its most descriptive, whereas with a smaller-scale subject you may be free to select and arrange the elements as you please.

Viewpoint is always a definitive factor in composition. Often the first impression of a view or an interesting object stimulates your mind's eye to form an idea of a drawn image. But this doesn't always mean that the exact position from which you first saw the subject is the ideal one. On closer examination you may see some aspect that is slightly disruptive — an ugly shape or a block of jarring colour — which could be modified if you moved your position to left or right. A slight shift of position may provide a more balanced or a more complex image, or you might decide to take an angle of view that enhances a characteristic element of the subject. By moving closer to some tall buildings, for example, taking a viewpoint that forces you to look upwards a little, you will be emphasizing height in the perspective of the drawing.

Colour in composition The information that the subject of the drawing provides includes shape, contour, volume, light

BELOW John Plumb's high-level view across back gardens to open countryside beyond incorporates a strong diagonal emphasis formed by the continuous line of fencing. The pastel colour is heavily worked to create the contrasts of light and shade, with a golden quality of reflected light conveyed by the warm browns and yellows. The colours are dragged and blended on the surface to re-create the textures of brickwork, wooden fencing and tangled tree branches. and shade, and colour. But you must decide how to put these together to divide up the picture plane. It can be difficult to juggle them all at once and, often, a particular subject presents itself more dynamically in one respect than in another. The immediate impression might be of a collection of forms that have beautiful contours, or a pleasing arrangement of blocks of colour and tone, or a fascinating range of detail, creating a network of intricate shapes. Gradually, as you look further into the subject, and in the actual process of drawing, the different components of the image come together. To begin with, though, it is helpful to identify dominant elements and use these as a framework for developing the other pictorial values. You can do this by sketching the composition in various ways to assess the visual possibilities.

Local colour The colour of an object or material under white light — the colour it naturally reflects — is known as its local colour. The bright mid-green of a leaf, the yellow-green of an apple, red rose petals, a blue vase, an orange book cover — in each of these descriptions, the colour is the local colour of the object. It is a means of identification, part of the information BELOW A detailed architectural view displays an almost geometric pattern of hard-edged cast shadows. Paul Hogarth combines line drawing with watercolour washes to convey the clarity of form and colour. The interesting shape of the composition derives directly from its subject. An irregular outline is traced by jutting balconies and minarets, then broken into the natural contours of the far landscape. The shadow pattern travels diagonally through the drawing from foreground to horizon.

Drawing With Colour

ABOVE AND BELOW Rapid sketches in coloured pencil give a good general impression of different compositional arrangements. The horizon level is kept constant: the horizontal stress of the landscape can be emphasized or opposed, with points of focus travelling along the horizon line or breaking through it.

LEFT An image of strikingly effective simplicity is achieved by focusing on a single subject and handling the chosen medium with confidence. In this still life by Annabel Blowes, the fluidity of the watercolour washes overlays the sense of solid form. The colours are allowed to fuse while wet, creating delicately mixed tones. The atmospheric treatment is unusual for what could be described as a relatively mundane subject, but there is also a disconcerting touch of surrealism in the ghostly fish lying in the shadows of the bowl.

that helps us to recognize things by their inherent properties.

Local colour is modified by a number of things: the quality of illumination: the effects of highlight and shadow on three-dimensional form: the object's surface texture; hints of other colours reflected from the surroundings. In an open landscape view, atmospheric effects of distance or weather conditions will alter local colour. All these influences on colour values will be examined in later exercises and projects, but for the moment we will concentrate on local colour as a basic component of composition.

Establishing a composition The simplest way to map out a composition is to deal with each component as a characteristic outline or block shape. As explained earlier, it is important to think in terms of colour from the earliest stages, and a good way to begin is to establish the viewpoint and general design of the image by drawing outlines or block shapes using only the local colours of each element of your chosen subject. For the time being ignore the tonal contrasts of light and shade and the complexities of pattern or texture, and concentrate on individual shapes. Look at their relationships as flat elements on the picture plane, working in terms of their arrangement within the "frame" of the drawing paper.

RIGHT One of the purposes of colour drawing may be to develop a composition for interpretation in another medium. Two working drawings by Elisabeth Harden (top and lower left), were preparation for a lithograph (far right). On the basis of a deliberately restricted colour range, the artist used the drawings to work out the general form of the composition and the way in which the colours could be overprinted in the lithography. The printed colour has a very different character from that of the gouache drawings, but each image displays a vigorously calligraphic sense of line and form, together with firm control of the colour values.

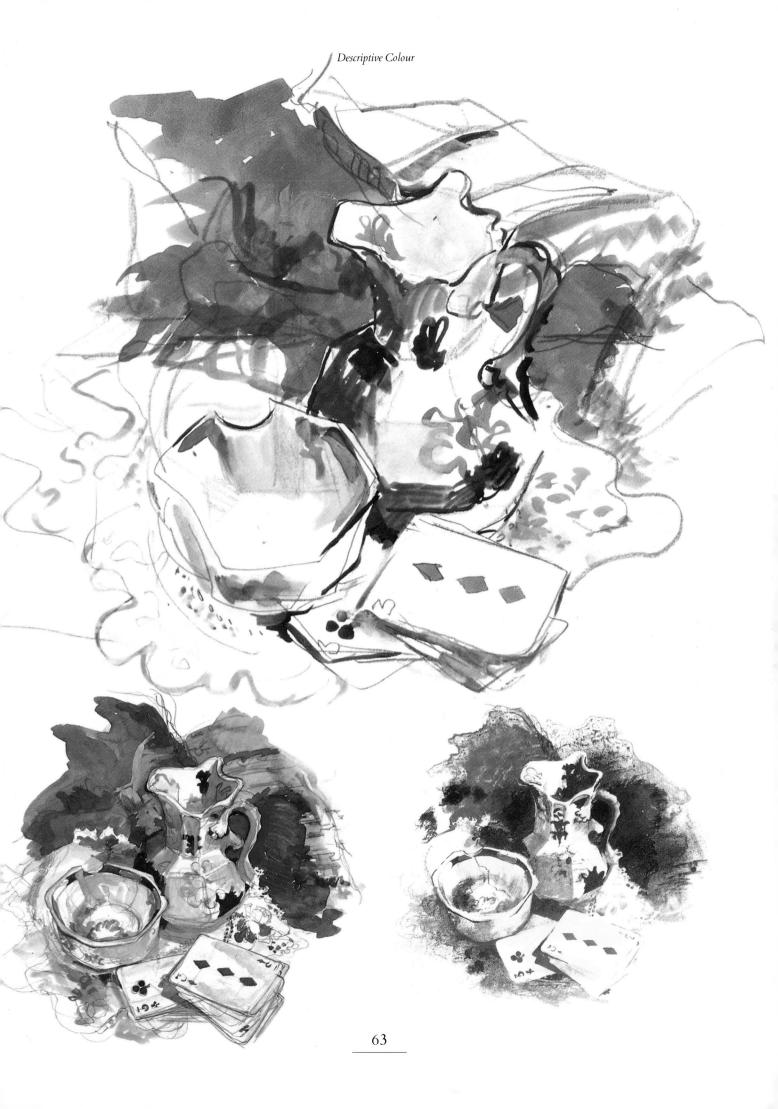

Drawing With Colour

RIGHT A drawing which concentrates on line can still make a feature of the colour values. A pen and ink drawing by Judy Martin picks up the cues of local colour in green and red variegated plants. The drawing technique allows a clear expression of the naturally interesting composition of the plant group.

Outline and silhouette The idea that things have outlines is more a convention of image-making than a reflection of reality. The outline or silhouette of an object is not usually a characteristic means of recognition, it is something you have to look for when drawing. If you start a drawing by mapping the outlines (which is not necessarily the best or only way to begin), you will find that as you work up details of form and texture, the original outlines become less and less important, and eventually obsolete. However, outlines have a useful function in planning a composition, helping you to chart the formal relationships of the various shapes within the image that will be used to build the overall design. They also help you

to focus on edge qualities that contribute to the rhythms and tensions in the drawing.

It is important to notice the "negative" forms in the composition — the spaces between objects and the shapes and colour values that they contribute to the image. When planning a composition, try to deal with these areas positively rather than allow them to happen by default as you concentrate on the more obvious forms.

Simplifying the colour context at this stage to lines or blocks of local colour, you can concentrate on the arrangement of the composition with attention to the following aspects of design in drawing.

Descriptive Colour

Balance and symmetry The balance of an image comes from the way you organize the distribution of weight and emphasis between basic shapes and colour areas. A symmetrical composition provides balance because it implies a mirror-image effect arranged on a central axis. In general, it is good practice to avoid symmetry — by shifting the axis off-centre or turning it at an angle — because equal divisions on the picture plane can create an even emphasis lacking visual stimulus. Sometimes it can be effective to use a central division that gives a strong axis to the image, but you need to consider carefully what happens on either side of this central focus. You can also create balance by giving unequal weighting to parts of the image, but organizing their scale and extent in such a way that they offset each other effectively.

Viewpoint Every slight movement of your head when you look at your drawing subject actually creates a slightly different viewpoint and subtly alters the composition. For practical purposes, the natural minor variations of eye-level and sight-line that result from making slight movements as you work can be ignored, but the general position from which you choose to work in relation to the subject dictates the sense of height and depth in the image. You can select a high, low or relatively level vantage point, a view that confronts the subject AWOVE Mike Hoare's energetic watercolour sketch transforms a soldierly line of palm trees into a riot of subtly varied coloration. The image works particularly well because the edges of the drawing have been allowed to develop openly on a white ground. Without the confinement of a conventional picture "frame", the even spacing of the tree trunks provides the basic structure of the composition over which the artist plays his colours freely.

ABOVE The general arrangement of a still-life group is roughed out in a watercolour brush drawing by Tom Robb. Beginning with a thin layer of diluted violet, he establishes the main planes of the composition: the horizontal tabletop and vertical window behind are just loosely suggested in pale to midtones. Using a stronger purple, he draws up the flower vase and fruits, at the same time indicating cast shadow areas with heavier colour. Gradually the process of overworking the brushmarks develops the tonal range and finally, small patches of local colour are worked into the pictorial structure

flatly or takes an angled view giving more depth. The viewpoint is described by the relationship of vertical, horizontal and angled planes within the drawing.

Framing the image The dimensions and proportions are something you establish to suit the general shapes and patterns of the subject. Within this framework, you may wish to contain the focal points near to the centre of the drawing, or allow shapes to be broken by the "picture frame" — the outer boundaries of the drawing area, which need not necessarily be the conventional rectangle. Such decisions relate to your chosen viewpoint and the impression of closeness or distance you want to create. Placing important compositional elements so that they "bleed" out of the frame suggests that the viewer is close to, or even within, the subject area; while greater distance is implied when it is only background elements that pass beyond the frame. Incomplete shapes can be used to create more complexity in the design, but are not always appropriate to the subject.

TONAL VALUES

There are two distinct aspects of tonal values in colour drawing — the balance of inherent tonal values in the local colours, and the effects of light and shade that modify the colour values.

"Tone" is a general term referring to qualities of lightness or darkness. It is easiest to think of this in terms of a monochrome scale from white (lightest value) through a range of greys to black (darkest value). A three-dimensional ABOVE A single colour can be used to plan the main lines of the composition, the quality of the line and additional touches of hatching, scribbled brushmarks and tiny dabs of washed colour build the basic picture. This is in effect parallel to the first stage of the drawing illustrated left. It could itself be elaborated in similar ways, or the artist might choose to create a whole series of such sketches, with minimal details, before deciding how to work up a selected composition more fully in colour.

Descriptive Colour

ABOVE This sequence shows stages in an exercise in composition, first establishing line and tone, next introducing local colour, then extending the colour range and finally redeveloping the pattern of light and shade. This approach is simply demonstrated with felt-tip pens.

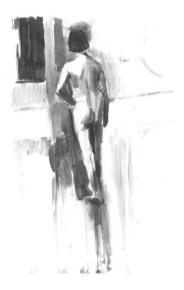

ABOVE Tom Robb uses a classic monochrome approach to a life study, modelling the form in terms of tonal values. The same exercise could be carried out with coloured pencil or pastel using shading or hatching, the result being a similar image but a quite different surface quality.

LEFT The textures in this colour lithograph by Tom Robb show the techniques applied to preparing the printing plates — brush, pen and chalk drawing. The three-colour interpretation is very effective, using the opposition of bright orange against deep blue and purple.

object reflects degrees of light across its external form according to the strength and direction of the light source falling upon it. The tonal scale of reflected light is independent of the local colour, but it can be difficult to perceive these tonal values accurately because of the relative values of different colours. Imagine a yellow cube standing next to a purple cube, both lit from above by the same light source. The upper plane of each cube has the lightest tonal value, because it receives direct light, but yellow is naturally seen as a lighter colour than purple so, in a drawing of the cubes, two tonal factors would need to be combined to render the colours accurately. ABOVE This sketch is similar to the related study shown at left, but it has a much looser, more open treatment expressive of the figure but less concerned with a solid sense of the anatomy. Brush drawing is a very free technique which can help to lessen inhibitions about a "correct" approach to drawing.

LEFT Elisabeth Harden's working drawing for a colour lithograph uses a controlled range of hue and tone to catch the impression of a detailed still-life group. The loosely washed blue-greys point up the bright yellows and oranges. The balance of the composition is subtly disrupted by the tall brush tips breaking out of the picture "frame".

ABOVE Tom Robb's small felt-tip sketch maintains an even tonal key and depends on the arrangement of blocks of related colour values to model form and space.

Form and space Tonal values are used to model form in terms of light and shade, and the shadow areas caused by the fall of light are particularly important in defining contour and volume. The parts of an object that receive little direct light—surfaces that are angled or curved away from the light source—show a gradual change from light to dark tones, while the side of an object facing in the opposite direction from the light source may receive no direct light at all, constituting the darkest value in the tonal range. The same applies to a hollow interior receding at an angle to the direction of the light that falls on the exterior of the object.

Schematic representations, as used in certain types of illustration and graphic imagery, are based on an assumed light source, and here the tonal gradations can be artificially plotted to create an effective simulation of three-dimensional form. But objective drawing presents a different problem, as the tonal variations in the subject may be quite complex. This is because it is quite unusual to have a clearly directed, single light source; often the light is spread or diffused, reflected back from different directions. Surface qualities also affect the way tonal variations are presented: a shiny surface bounces back more light than a matt one, and overall tonal gradations LEFT Despite an emphasis on tonal balance, across the full range from very dark to luminously pale, Adrian George infuses both shadows and highlights with masses of vivid colour, using pastels and crayons to create a densely woven texture.

ABOVE This drawing takes a conventional monochrome approach to the subject of boats silhouetted on open water, but Tom Robb has enlivened the simple interpretation by using two distinct values of blue — a dense cobalt and the sharper cerulean.

are often easier to see on a smooth surface than on a heavily textured one. Pronounced textures, indeed, create a highly intricate tonal network of their own, which coexists with the patterns of light and shade across the underlying form.

The other main function of tonal values in a drawing is to locate the subject in relation to its surroundings by means of cast shadow — the shadows that occur when an object stands between the light source and another object or surface, thus blocking the passage of light. Cast shadows, such as that thrown by an object standing on a table top, help to provide a more authentic sense of spatial location in an image. Sometimes, however, they can cut across and confuse the tonal gradations that model a form, and this is something you should consider carefully when you are arranging a portrait or still-life grouping.

Tone and colour To judge tonal values correctly, it helps to think of the effects of light and shade in terms of a monochrome scale, but this does not exactly explain how these can be translated in colour drawing. If you depended on a system of adding white to lighten the tones and adding black to darken them, you would achieve a rather dead quality in ABOVE A high contrast of tones gives dramatic impact. Vincent Milne has made use of this effect in his mixed media drawing of chimneys, silhouetting the strange and rather menacing shapes against areas of brilliant, harsh colour. The powerful structure of the composition is reinforced by the emphatic contrasts. But although the oil pastel colours have been thickly laid over the base layer of high tones, there are variations of broken texture throughout the image that provide pinpoints of light and shadow complementing the larger plan of the tonal values.

ABOVE Mike Hoare's watercolour landscape is described in restrained achromatic and neutral colours, with occasionally stronger touches of redbrown and green which emphasize the tonal range. This enhances the effect of distance and captures a subtle, even light spreading across the landscape. the picture surface. Since we know that white light is composed of colours, we can assume that highlights and shadows have some colourful qualities. You will also find that black pigments reduce the interaction of colour values between pure hues, giving a corresponding reduction of subtlety in the surface effects.

If you look carefully you will probably notice that there are distinct colour shifts in highlights and shadows, and you can use these to enliven the tonal values. A highlight area may have a slight yellow or pink tinge under warm light; shadows on a yellow object may have a green or red tinge, depending on the quality of light; a blue surface may shade into cold purplish tones where it falls into shadow. Some of these effects are innate properties of colour values produced by a combination of local colour and surface texture under a directed light. Others are more dependent on reflected colour from surroundings or adjacent objects — these are discussed more fully on page 80.

The tonal patterns of a subject can be broken down by using colours — perhaps gradations of a single colour or a limited range corresponding to the darkest, lightest and one

ABOVE Very quick sketches can convey the atmosphere of a landscape view using minimal variations of tone and colour. This pastel simply describes the vast space of an open landscape and cloud-studded sky.

LEFT AND BELOW Brief pastel sketches by Tom Robb use limited colour ranges to study mood and tonal scale. A shadowy impression of a canal in Venice is unusually interpreted in close-toned hot pinks and reds (left). In thumbnail sketches of a lighthouse against a flat horizon (below), he gradually distils the tonal scale, from a four-colour range to a simple monochrome range.

RIGHT A page from a sketchbook kept by Andrew Bylo includes several engaging details which have caught the artist's eye, quickly noted down with brush and watercolour.

or two middle tones. When you have studied a subject in terms of tonal rather than colour values, try putting together the tonal gradations with the blocks of local colour as previously described, and you will then begin to build a composite picture of the forms and colours.

A useful exercise in "thinking in colour" in relation to tonal variations is to try creating "coloured" blacks and greys by using combinations of various hues. Blue, purple and brown will mix to produce a rich dark tone that might stand for the darkest shadow areas in a drawing, eliminating the use of pure black. Experiment with combinations that vary the warm or cool qualities of the mixed darks, and the depth of dark tonal values according to the number of colours you have interwoven. In the same way, you can develop light tones using bright or pale hues: open techniques of hatching and stippling can give subtle colour to an area that will still appear white in the drawing when it is set against the heavy, dark tones.

Sketches and studies It is not usual to make studies for a drawing — drawings are often regarded as studies leading to works in other media — but since a full-colour drawing, particularly if it is an ambitious composition, takes at least as much time and effort as a painting, it makes sense to work out some of the problems beforehand. Sketches or studies based

on the shapes, colours and tonal values of the image can be used for this purpose in the same way that you might use them to provide reference for a painting.

As well as planning the general shape of the composition and looking at the subject as basic blocks of colour and tone, you might find you want to work on detail studies for particular aspects of the composition. For example, in figure work, many people find hands more difficult to draw than faces; for a landscape view, individual studies of trees and smaller plants might prove valuable. If you have an idea of which parts of the subject could cause problems, preliminary studies will help to give you a sense of what you are aiming at.

This preparatory work reduces the risk of making a major error of judgement that could spoil a drawing when you have already put in a lot of time on the initial stages. It can range from little thumbnail sketches that give you a feeling of the subject to sequential studies providing a thorough examination of particular features. You can also use such studies to test the effects of different media to find out which materials give the most suitable colour quality and surface texture.

BELOW This watercolour by Ian Ribbons is highly descriptive of place and time, capturing the effect of late autumn with the still-warm colours of turning leaves and trees already bare of foliage. The basic structure is sketched in with a brush in broken line, the colour detail developed with lightly patched-in washes.

Descriptive Colour

LEFT Often the particular charm of a colour sketch comes partly from the fact that it is not a finished image. In this riverside view the white spaces activate the already vigorous colour work, which includes resist techniques, dabbed and blotted textures, and line drawing with brush and pen.

COLOUR ACCENTS

BELOW Ian Ribbons develops a quite different mood in this townscape sketch,

the active dashed and dotted ink line

yellow and neutral colours laid in to

convey the flat façades of the sunlit

area.

buildings, and more emphatic hues and

tones splashed into the busy foreground

suggesting the mood, with pale washes of

It is possible to create an effective description of objects and their location by using only local colours and tonal values. But although the task of simplifying what you see helps you to recognize how to organize a composition, you cannot help noticing the variety and subtlety of colour values in even the most basic subjects.

Drawing With Colour

All surfaces, even those that are not highly reflective, will pick up some colour influences from the prevailing light and the surrounding colours. Sometimes these are mere hints of colour, but all such accents serve to modify the appearance of local colours and create the more complex network of colour values in a given context. If you look closely at the petals of a white flower, you may identify traces of yellows and greens in the white, blue or purple tinges in the shadows, a hint of warmth where the outer edges of the petals catch the sunlight. Some of these colour emphases belong to the texture and colour of the flower itself, and others to the influence of its surroundings. To catch the small accents of colour in a

LEFT Tom Coates selects a subdued range of browns on buff paper to establish the structure of this pastel drawing, developing a strong tonal scale by the intensity of white highlighting in the window area. Into this tonal scheme, he introduces vivid colour accents of deep pink and clear blue-grey.

composition you will need to pay close attention to detail. This is true for all subjects, and is not always just a question of delicate surface changes, such as those described in the flower. In a broad area of landscape, for example, you might see a blue shadow among the greens, or a yellow patch of sunlight, or a scattering of vivid red flowers. If you were designing a room, you would be conscious of deliberately contriving colour accents by adding bright cushions or ornaments to a coordinated room scheme, and the same principle applies to drawing and painting — you incorporate touches of colour that bring the image alive. All such elements create points of

ABOVE Sally Strand accurately identifies every tiny shift of colour emphasis which creates the lights and shades of her "Men in white". The network of vibrant colour in the shadows, with purples, blues and yellows woven together on the warm yellow-brown ground of the paper, demonstrates the artist's exceptional skill in colour analysis.

Descriptive Colour

focus and contrast that make a colour rendering more interesting and, usually, more real.

Surface qualities One of the most difficult problems in colour rendering is to find technical equivalents for the surface textures seen in the subject. Some surfaces produce complex and confusing colour combinations while others are blandly smooth, giving few clues as to the precise characteristics that explain their physical quality.

A plain-coloured matt surface contains little colour variation. Gradations of reflected light or colour are minimal, and tonal shading corresponds to the way light models the form. A patterned surface — such as wallpaper or printed

LEFT The subdued grey-blue tones of the harbour wall lined with ships are loosely touched in with ink and watercolour, but Ian Ribbons makes full use of the focal point of brightly coloured flags in the foreground. This not only provides an interesting colour balance, but emphasizes the deep perspective of the view.

fabric — is obviously far more various in terms of local colour, and this can disguise the effects of tonal modelling that would be more easily distinguishable in an expanse of single colour. One way of dealing with this is to treat the subtle shifts of coloration in shadow areas in the same way for each colour within the pattern. This, although producing a complex surface in terms of drawn marks and their relative colour values, does create a coherent sense of overall form.

Pronounced textures, such as those of brickwork or tree bark, will usually form an irregular pattern of colour and tone. This, once identified, can be simulated by equivalent marks and blocks of colour in the drawing. Sometimes it is useful to exaggerate a textural effect to give emphasis to different surface qualities in different objects. Your viewpoint also affects the influence of actual texture in the general impression of the subject. If you see things from quite a distance, emphasizing surface effects may break up the balance of the composition by drawing attention to one area more than another. In closer studies, though, texture has a more important role in identifying objects, and the technical ways in which you render such characteristics can give liveliness and force to the finished image.

White still life

Working from an all-white subject is an interesting exercise in colour analysis. White surfaces typically contain stight colour biases and hints of reflected colour from their surroundings. The artist needs to identify the colour accents that give liveliness and depth to the drawn image, and convey them in a way that maintains the overall "whiteness".

It is naturally easier to use a tinted ground as the base for the study than to work white over white. The paper colour may provide a dominant colour value, or form a base that complements the drawn colours.

The first step was to try out different groupings of the objects (top left) in small thumbnail sketches, marking the perceived colour tints quite strongly. The arrangement selected for the final drawing was one that seemed to best bring out the colour variations while making a balanced composition. The tints in the ceramic jugs ranged from yellow through pink and mauve to blue-grey. Small studies were tried on light brown papers, but gave too warm a cast to the image. The grey paper of the original sketches formed a more subtle base for the development of lights and shades as well as colour values.

In the final image, drawn with coloured pencils and pastels, the technique was kept loose, with scribbled, hatched and cross-hatched marks, so that the colour tints could be continuously interwoven with pure white.

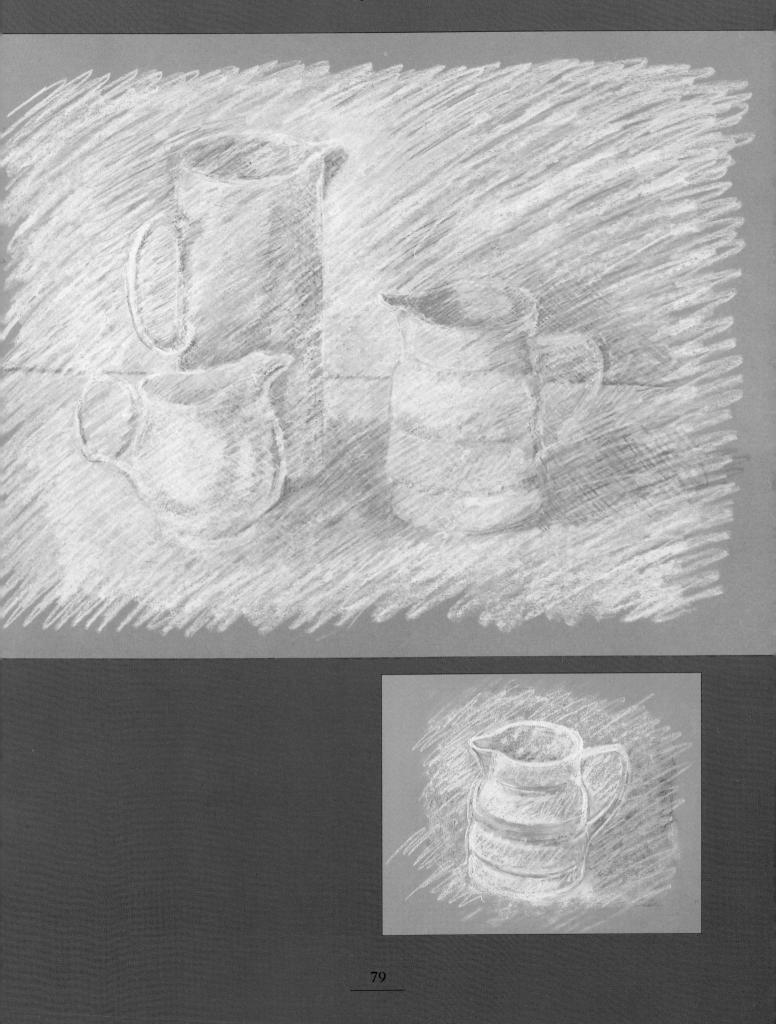

Reflections Materials that are highly reflective do have their own colours — think of the warm red tones of burnished copper for example—but the visual impression they give is to some extent a composite of colours. Where they receive direct light you will see dazzling highlights, sometimes strongly contrasted with dark tones on curves and angles, and there will be a range of reflected colours picked up from those of neighbouring surfaces and objects. You may also see some unexpected influences from quite a distance, especially if there is a strong lighting effect farther away. An object standing in light from a window might reflect faint sky tones and sunlit yellows, while interior light sources such as a coal fire or candles throw warm, flickering tints that can strike quite vividly on a reflective surface across the room.

The more reflective a surface is, the more pronounced the contrasts of tone and colour. Although the initial effect is confusing, materials such as chrome, silver and glass offer distinctive shapes and patterns in the reflections that are relatively easily identified once you start to study the subject closely. In strong light, tinted glass can be as completely reflective as an opaque, shiny metal, as seen in the glass-clad façades of modern buildings, which mirror their surroundings in astonishing detail.

In a solid or hollow glass object, the colour effects derive both from the reflected colours and those seen through the transparent material. It is the combination of these elements that visually define the quality of "glassiness": colour treatment in the drawing must explain the relationship of surface effects and transmitted colours in a way that represents the whole object coherently.

A material with surface sheen can be a more difficult problem in colour rendering than one that is polished and shiny, because the tonal keys are less dramatic and the colour shifts more subtle. Whereas with high-contrast reflection you see hard edges and clear contrasts of colour values, the lower tonal register of, say, aluminium or varnished wood will include softer gradations and muted, mixed hues that can be hard to distinguish. They are related to the surfaces they are reflecting from, which provide the colour cues, but the reflected colours are seldom if ever as pure as the originals, so you must look carefully at both the original source and the reflected values.

Reflected colours in landscapes provide additional depth and detail. In a snowy landscape, for instance, there are different qualities of whiteness, and there are washes of colour in the lights and shadows that relieve the starkness of form masked by snow. A pool of water can provide an impressionistic reflection of general shapes and colours or, like a mirror image, show the clearly delineated forms of surrounding trees and the clear colours of the sky. LEFT A lithograph by Ellen Gilbert recreates the gentle textures of ink wash, brush and chalk drawing. The subtle transition from the yellow-green cacti in the foreground through clear yellow to blue is enlivened by accents of red travelling around the central curve of the composition, across the plant tips and along the jetty to the flat top of the moored boat.

LEFT Hugh Barnden's sunny window view maintains a high-key range of colour — yellow, blue and mauve — and uses linear detail to define the structure of the composition. The geometric lines of the windows and the decorative balcony rail are traced in a warm mid-tone against the cool tints of the colour blocks.

COLOUR KEYS

The "key" of a drawing is its overall impression of lightness or darkness, and its colour emphasis, such as blues in a seascape, greens in a landscape, reds and yellows in a warm interior. A colour scheme is said to be "high key" if it includes a high proportion of pale tones or brilliant colours, while a "low-key" scheme might consist of large masses of dark tone, relieved by highlight areas and colour accents. However, an image basically composed of muted middle tones would also be described as low key, whereas mid-toned primary and secondary colours with coloured shadows would create a higher key.

To assess the general impression of a subject's key, it helps to half close your eyes, cutting down on the details of light and colour that you physically receive. You will then find that some colours and tones merge together and you can identify the most basic values of light, middle and dark tones and the tendency of the colour values towards specific colour families, such as red or blue, or general categories of colour quality, such as warm or cool, vivid or neutral. This approach also helps you to decide on your scale of colours and tonal ABOVE The fur of a black cat seen under strong sunlight gives off many hints of colour. In this graphite and coloured pencil sketch, Judy Martin extends these colour values to express form and texture.

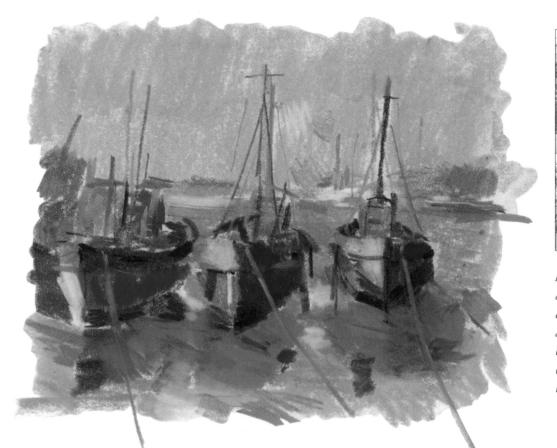

ABOVE In this crayon and watercolour drawing the artist has adjusted the overall key of the image by giving the flat areas of grass a very intense, bright hue balanced by the vivid greens forming the middle range of tones. This increases the impression of brilliant sunlight.

ABOVE You can choose to interpret a subject in a high-key colour, even though it may contain areas of deep shade. In this pastel sketch, Tom Robb converts the tonal balance to pure colour values, using a dense bright blue for shadows that would normally have dark tone, to make a definite contrast with the warm reds, oranges and pinks corresponding to areas of the subject receiving more light. These two extremes are linked by the soft mauves standing for the middle tones. values, which sometimes needs to be controlled and limited by comparison with the many incidental colour effects in the real subject. Too many shifts of colour and tone within a drawing can confuse rather than enhance the sense of form and space.

Certain subjects readily suggest their colour key and its tonal values. A sunlit landscape of open fields, for example, is naturally highkeyed compared to a view into a densely wooded copse where there are strong shadows and natural darks in the trees and foliage. Similarly, a large-windowed interior seen on a summer's day with light flooding through the windows has a quite different colour character from the same interior in artificial light or lit by low, wintry light from outdoors. In some circumstances, you will contrive a colour key as the basis of a drawing subject — in setting up, for example, a still life of red, orange and purple fruits and vegetables rather than those that provide a range of greens and yellows.

Colour accents can be used to help to emphasize a distinctive key. In a darkly shadowed interior or woodscape, tiny flashes of yellow, pink or acid green will emphasize the richness of the dark colours and tones without actually balancing them out. Where you have a naturally balanced subject, in which light, dark and mid-tones are relatively evenly distributed, you need to locate one particular colour

Descriptive Colour

that will form the basis for developing the colour relationships. This might be a background colour giving overall colour and tone — the tradition of pastel drawing on tinted paper serves exactly this purpose, using the paper colour to set the middle tone. You might prefer, however, to first identify the well-defined areas of highlight and shadow that establish the lightest and darkest extents of the scale and then work within that range.

The quality of a dominant colour is very important. You can ruin the general effect of a landscape, for example, by starting out with a broad area of green that is too blue or too yellow, too dark or too light, which then influences the

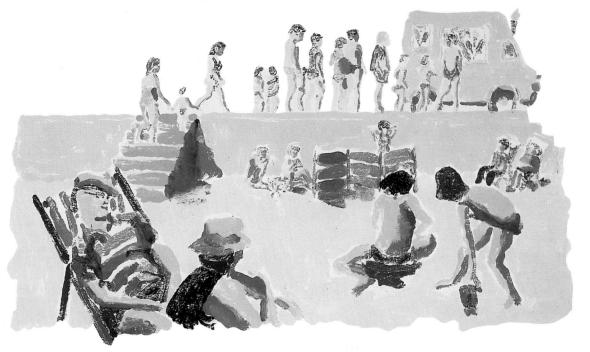

developing colour relationships. Fortunately, this is less likely to happen in drawing than in painting, as you are usually building up mixed colours gradually and continuously working with relative values; in painting, when you have put down a solid slab of pure colour, it can be difficult to realize that this is subsequently providing the wrong basis for working up the overall colour key.

On a practical note, when you make preliminary sketches to determine the colour key of a composition, it is advisable to work with a medium that allows broad strokes and massed areas of colour, such as pastels, markers or watercolour. With these you can quickly block the effect of an overall scheme, which gives you a basic construction for the drawn image. When you start to work on the final version of the drawing, you can feel confident about first establishing this general scheme based on the information in your sketches, and you can then develop the more complex aspects of surface quality and colour accents. ABOVE Pauline Turney's beach scene includes the kind of "bleached out" colour effects that occur under strong sun, enhanced by the combination of flat colour areas and broken texture.

LEFT The base of dark sepia-toned paper used for this pastel study of musicians sets the overall low-key impression, but Tom Coates has enlivened the surface with tiny dashes and streaks of high-key colour.

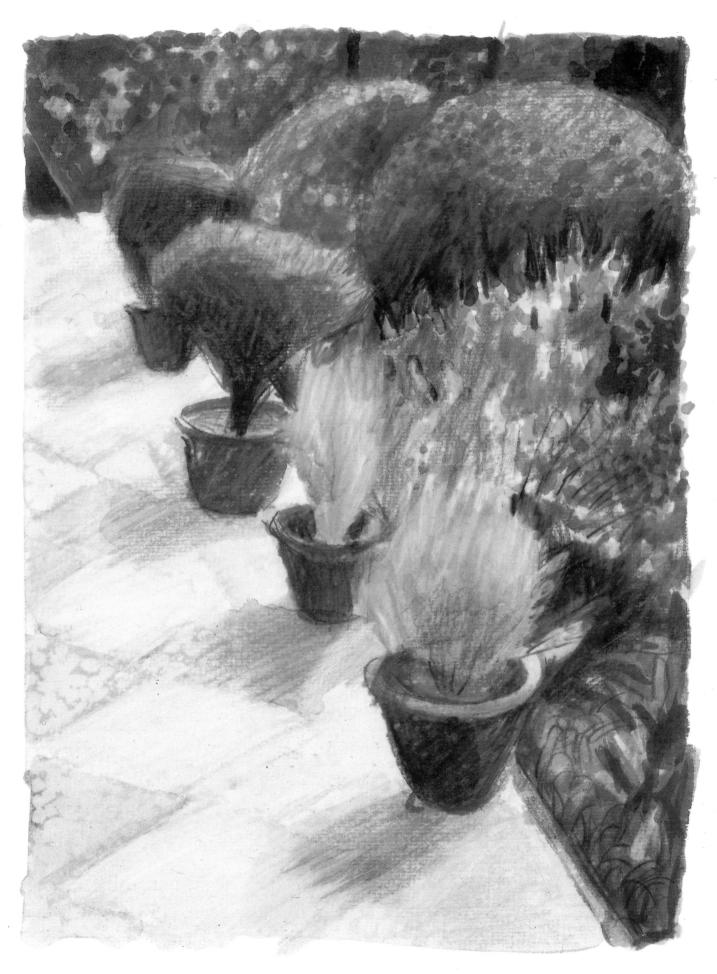

Atmospheric Colour

LEFT Fluid transitions from bright sunlight to deep shade create the atmosphere of Jane Strother's attractively planted patio. She uses a deep blue watercolour base for the shadow areas, yellow for the strongest highlights, and merges these two elements through dabs and streaks of watercolour overlaid with coloured pencil hatching in a middle range of greens, blues, and reds. The title of this chapter refers to those qualities of a subject that do not contribute to the basic elements of form and colour, which have already been described, but to the sense of time, place, and specific conditions. We spend our days moving between indoor and outdoor locations, absorbing almost instinctively a distinct feeling of the differences between them. These differences exist not only in the simple terms of open or enclosed spaces, but also more subtly — in light, air and vapour, transient effects that move and change within the given frameworks.

You cannot always see these things as material colours and textures for which you can find equivalents among your drawing materials. They are insubstantial elements that create the atmosphere of an image, acting upon the solid, material qualities of the subject, but their effects can be seen and identified if you train yourself to unravel the different levels of visual information you receive. You will then be a step closer to understanding how to describe them in drawing. BELOW Watercolour is the obvious medium for misty atmospherics, but it can also have a sharp graphic quality as a result of puddles and streaks of wet paint being left to dry naturally, when the colour tends to accumulate most strongly at the edges of the shapes. Graham Dean exploits the medium's varied qualities in a panoramic image spread across overlapping sheets of thick watercolour paper.

ABOVE An abstract image in cold browns and greys calls upon the viewer's imagination as to the time and place, but the sense of bleak spaciousness is pervasive. This drawing by Sue Emsley mixes paint and ink with paper collage. Because you have, of necessity, to play an interpretive role in capturing these elements, it is particularly helpful to study how other artists have conveyed atmospherics in their colour work. Look, for instance, at Cézanne's shimmering, faceted landscapes, Bonnard's colourful, sunlit interiors, Constable's cloud-laden skies, Turner's swirling seastorms, and the Impressionists' grasp of a range of atmospheres as variable as summery riverside scenes and the smoky townscapes of encroaching urbanism. These are, of course, mainly seen in paintings rather than drawings, but the two disciplines always overlap, and if you study the brushwork carefully you will find parallels with drawing techniques. There are also more recent

LEFT Tom Robb contrives an extremely effective atmospheric landscape with bands of colour hatched with felt-tip pens. The directional strokes enhance the brooding presence of the heavy sky over the flat landscape. By overlaying layers of colour, the artist has achieved some subtle mixes, qualifying the sometimes rather brash effect of this medium.

ABOVE Markers and felt-tip pens are particularly convenient for colour sketching outdoors and can be handled in a way that provides a descriptive record of the mood of a scene. This quick colour exercise notes the mirrored effect of a lake reflecting the mountain range behind. examples of colour drawings by contemporary artists that grapple with similarly complex effects of light and colour. Sometimes it is by borrowing or adapting another artist's solution that you come upon something that is all your own. In any event, learning from others is never wasted, as it complements the direct analysis you apply to your own observations.

SPACE AND DISTANCE

Atmospheric perspective — also called aerial or colour perspective — is a device that has been used for centuries by painters to enhance pictorial depth and the sense of distance in landscape compositions. Unlike linear perspective, which depends on scale and contour to develop spatial relationships, atmospheric perspective is an effect derived from particular perceptions of tonal and colour values. In the foreground of a landscape, colours are at their brightest and most intense, the tonal contrasts are at their most emphatic. As the image recedes into the middle distance the definition becomes less pronounced and the range of colour values diminishes, narrowing in the far distance to a scale consisting mainly of blues and greys. Details of form are also gradually eliminated BELOW Natural features of the landscape often provide strong cues for the arrangement of a composition. In this view, Jane Strother makes use of the linear pattern of a plantation to lead the viewer from the foreground of the picture into the horizontal spread of the middle ground. There is an interesting perspective in the undulations of the land and the artist has selected a relatively high viewpoint. The natural greens are shot through with yellow lights and dark blue shadows, the scheme of colour fading gently towards the distant horizon.

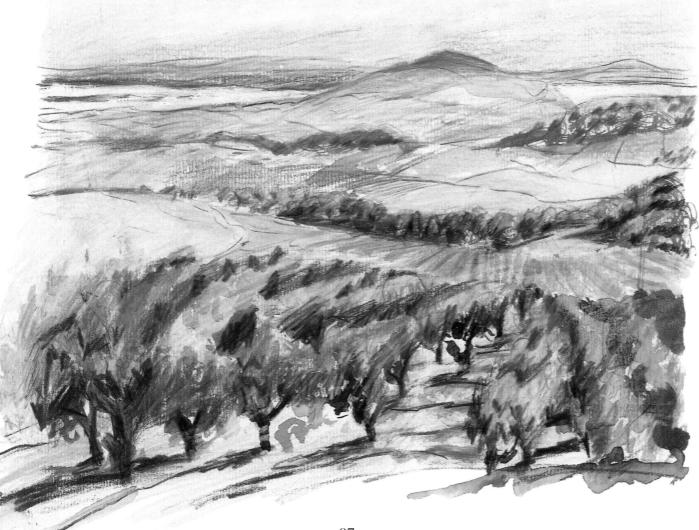

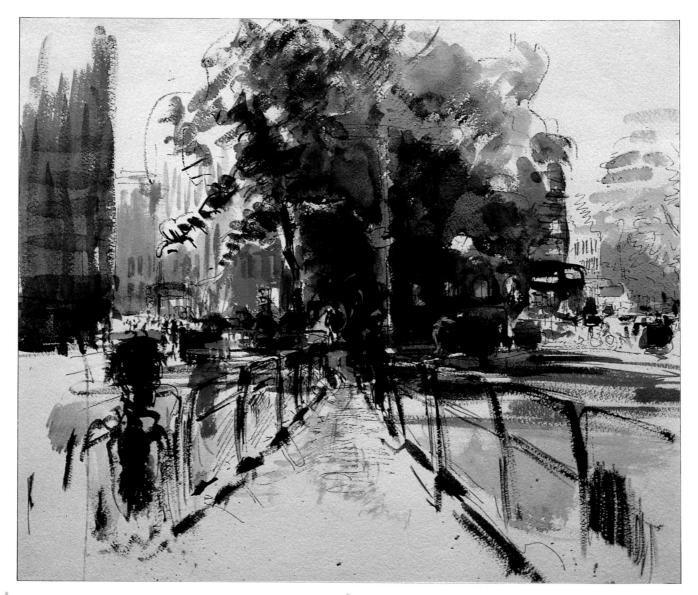

so that background elements are presented in terms of broad masses lacking distinct and individual features.

You can see this occurring in an extensive landscape view. It is an optical effect caused by vapours and particles that hang in the air and, with increasing distance, create a "veil" that softens the edge qualities, surface textures and colour and tonal contrasts. The convention has been used successfully in images ranging in style from meticulously realist to broadly impressionistic. It illustrates the general principle that colour relationships contribute significantly to pictorial definition of space and form.

If we look at this idea in greater detail, we can see it in terms of a more abstract idea of colour interactions. A flat area of a single colour creates no particular spatial sense, but as soon as we add a second colour or a different tone of the same colour there is an immediate tension, which begins to suggest a spatial relationship. This may be an effect of light and dark tonal values—the lighter colour seeming to advance from the darker; or one of warm and cool contrast—a strong deep red, for example, forcing its way out from a cool mid-blue. It may be the way an intense colour interracts with a sombre one, as with a brilliant sunshine yellow flashing across a muddy ochre. In general, it can be said that contrasts create space, while evenly balanced hues and tones tend to compete for spatial dominance.

There is also, of course, a structure within a composition — created by contrasts between linear elements and mass, or the relative scale and interplay of shapes. To produce a naturalistic rendering, you need to make the colour values work with the other formal elements of the composition. If you arrange colours and tones to act against the framework of the pictorial space, you are reinterpreting the image in a non-objective way that acts to flatten depth and form. These effects of colour balance apply to any definition of the picture space whatever its extent and however it is organized — as important in the limited spatial context of a half-length

ABOVE In a small pastel sketch, Tom Robb employs bright, distinct blocks of colour to re-create the atmosphere of a park scene in brilliant sunshine. Strong patches of yellow, orange, violet and pink are used to interpret the artist's impressions of form, light and shade.

LEFT Ian Ribbons captures the sombre mood of a city view using neutral greys and browns merging into yellows, greens and blues. The perspective of the composition leads the eye into the shadowed centre of the image from where the activity of the busy streets fans out on either side. Contrasted areas of light and dark tone enhance the sense of space and structure. portrait as in the much greater, more open space of a landscape or townscape.

The greater the actual distance you wish to convey, the more alert you have to be to the colour cues that make the image work. In a broad landscape where there are dominant colours such as greens or earthy browns you have to examine how these change with distance, and which precise values of tone and colour will "pull forward" the foreground plane while "pushing" the distant areas away. Sometimes it is necessary to play up the brilliance of foreground colours, or the tonal emphasis, in order not to lose the diminishing scale of values in the background.

The pictorial arrangement of colour also depends upon where you want to place the point of focus in your drawing. If you have an interesting focal area in the middle ground, this has to be "played" in the right key against the foreground and background so that it does not become only an incidental part of the image. You may find that the darker tones defining this area are in the middle range of the tonal scale, and the values used to describe closer objects need to be carefully adapted in their apparent contrasts. The foreground must be treated in a way that establishes its closeness but leads the eye towards the focal point in the middle ground.

TIME AND SEASON

Surface effects of colour and tonal modelling are influenced by the direction, strength and colour quality of the light falling on them. The quality of natural light changes according to the time of day and season, so if you can capture a particular quality in an outdoor subject, you will add an extra dimension to the sense of location. It is described by the overall colour key, the relationships of the areas of light and shade and the individual notes of colour provided by highlights and colour accents.

You can probably call to mind occasions when you have been struck by a particular quality of illumination on a familiar scene that gives a sudden strange beauty to a normally mundane view. There is a kind of late afternoon light that in the city causes tall buildings to stand out as golden planes against a darkening sky. There is an intense midday effect in high summer when the light is so strong that it almost washes out colours, and there is a harsh, cold light when winter sun reflects off snow. We can call to mind many of these general impressions, especially of extreme conditions, but it is not always easy to define precisely the relative values that create them.

The task of studying such effects to reproduce them in drawing is made more difficult by the fact that they are by nature transient. You cannot sit all day watching the colour of BELOW At first glance, the shadows through the archways appear inky black. Looking more closely, it is evident that this density comes from rich blues and muddy greens. The dramatic tonal contrast of Pauline Turney's gouache sketch produces a strong image, and there is an excellent sense of structure in the balance of ragged lines and solid patches of colour.

ABOVE In this watercolour sketch by Ian Ribbons, a combination of fluid colour washes and a scratchy, linear drybrush technique achieves a lively rendering, making full use of the variety of textures in the subject. There is a strong impression of light, obtained by contrasting the dense foliage colour with the stark white gatepost and allowing the edges of the drawing to find their own form against the white paper.

RIGHT The strange hard light that sometimes precedes a storm is conveyed by the sharp contrast of bright orange against grey-blue in this pastel and gouache drawing by Judy Martin.

afternoon light. You can hope — but not guarantee — that a similar quality will appear for a time on another day. This is an area where acute but rapid observation is needed, where you must train your memory as well as your eyes to take in the colour cues and learn to trust your responses to the passing moment. When working on a fully rendered drawing you may have to be dependent on sketches and colour notes rather than direct observation.

ABOVE It is very difficult to achieve a quality of night light, as the darkness has a paradoxical translucency. Vincent Milne succeeds in reproducing the effect with blended pastel colours, and enhances the effect of dim light in the sky by silhouetting the buildings as hardedged, solid shapes.

RIGHT John Plumb makes clever use of shape and colour to represent clear afternoon light creating long, dark shadows. The angle of the cast shadows is one significant element; the colour changes in the shadowed details of the hanging plants and swing frame give the image even greater depth and authenticity.

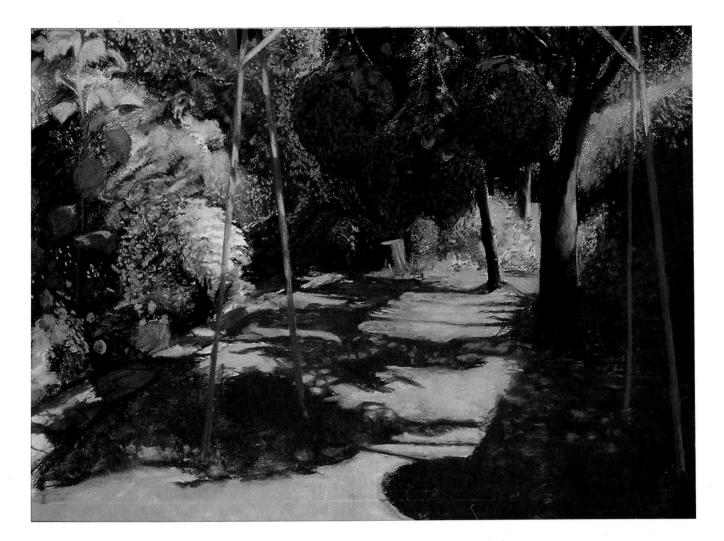

To make these rapid studies, you can for the time being give secondary consideration to form, which will not change and can be studied at more leisure. You need only to sketch out a view roughly to make a "map" on which the colour values can be located. If you have a particular subject in mind that you can revisit over a period of time, it might be worthwhile making line sketches that you can photocopy, using the copy sketches as the basis for colour notation to save time and allow you to immerse yourself in studying the transient colour effects. However you arrange your opportunities to study the subject, there are particular elements to look out for that provide the necessary clues to the qualities you wish to capture.

When you are looking at a subject in which there are large blocks or areas of local colour, try to identify the precise colour values both in relation to each other and to the source of illumination. In a townscape, for example, a white wall may be washed with a yellow or pink tinge that seems very vivid against a clear blue sky. In landscape, look at the range of greens, their clarity and colour bias towards blue or yellow. In the garden, think about the colour changes between the solid materials of walls, paths or fences and the more complex colour values of the plants and grass.

It is the tonal scale of a drawing that makes or breaks the sense of illumination, and this must be observed not only in terms of colour intensity and light or dark values but also with close attention to edge qualities and gradations of light and shade. Do the shadows that model form show abrupt transitions between light and dark, or a wide range of middle tones? Does the light emphasize contours, creating hardedged shapes, or soften and merge the forms? Does it etch the textures more strongly, or underplay surface differences? Cast shadows are crucial to a strong lighting effect—do these have heavy tonal density and solid outlines or a more fluid, amorphous presence? What is their direction and extent in relation to the light source?

At the same time, be alert to the colour qualities in the shadows as these will later help to give surface activity to the colour rendering. Look for dark tints of blue, green, purple or red in shadows, as these provide colour cues that can be played off against the lighter tones. Note also which shadows are in fact neutral in colour value, but for this very reason have

Drawing With Colour

ABOVE AND BELOW Shadow patterns are described in different ways in these drawings, in one by distinct colour changes, in the other by a tonal scale.

CENTRE Daphne Casdagli's mixed media drawing conveys the strikingly picturesque character of the buildings, with their weathered stonework and staggered pattern of windows and doors. The composition is given an asymmetric balance by placing the small dark alleyway just below the centre of the drawing, leading the viewer into the image. A heavy vertical line of shadow rising at the left anchors the more open forms to the right of the image. The chosen viewpoint emphasizes a sense of enclosure which is complemented by the warm browns and yellows applied to the stonework.

ABOVE AND BELOW Cast shadows on the ground form linear patterns in these two tree studies, both treated with a tonal range of emphatic contrast.

the effect of intensifying the pure hues and pale tones. Finally, look for the colour accents — not of local colour, but of reflected colours and highlights. Under certain lights, these may reflect an intense pink or gold, or perhaps cold bluish tones. Compare the depth of reflected colour according to the surface quality — whether there are distinct patches of solid colour or subtle passing tints.

Shadow patterns Cast shadows are especially illustrative of the way light spreads at different times of day. The strong overhead light of midday creates contained patches of dark shadow closely linked to the subject. Morning light is angled but naturally weaker in intensity, making less emphatic cast shadows, but these are particularly pronounced in late afternoon, when the angle of the sun is low and dark shadows extend from the objects that create them in strange, distorted shapes.

An atmospheric effect of cast shadow is the dappled light that falls through tree branches and plant growth. This makes a softer, more spreading pattern than the hard-edged shadow silhouettes thrown from individual, solid objects, but it is

ABOVE A sunlit orchard of apple trees in blossom provided attractive inspiration for a pastel and gouache painting by Judy Martin. The lines of the slanted trunks and cast shadows form a pattern of dark stresses through the high-key colours. The pastel strokes are slashed and scribbled across the watercolour base to suggest the impression of flickering light through the foliage and blossom. extremely descriptive, and gives an opportunity to weave rich colour effects passing from light tones to dark.

Heavy cast shadows and the substantial modelling of form created by strong, angled light provide a sense of drama. In pictorial terms, the light source may lead in from one side of the picture plane, giving slanted emphases, or it may seem to fall from a high point directly behind the viewer, flattening form and texture in the frontal surface effects but creating pools and receding streams of shadow on the ground plane. The light source may be located behind the central objects of focus, creating a dramatic backlit effect in which outlines are "haloed", and surface details thrown into deep shade.

Re-creating light and shade The atmospheric effects of illumination are represented in the interplay of colours and tones across surface qualities. To obtain the sensation of luminosity, rather than the more basic balance of the tonal range, you can afford to put considerable emphasis on the intensity of colour in pale and brilliant tones and play this up against the darker values.

The additional subtleties of warm/cool contrast also assist the luminous colour effects. In a high-key image or one in which the darkest tone is in the middle range, the shadows may contain cold blues and purples of relatively light-toned

ABOVE Judith Rothchild's pastel drawing beautifully captures the varied accents of colour in dappled light falling through dense foliage in a botanical garden.

value. These suggest a different spatial relationship to the direct source of light when offset against warm yellows, oranges and light reds.

Another element that increases the effectiveness of the colour composition is a developed sense of balance and counterbalance between light and dark values. Because colours and tones have different apparent weights you can activate the balance of the image by setting a tiny area of deep, dense colour against a broad expanse of a pale colour or more brilliant hue. The reverse of this would be to emphasize a vivid highlight to enhance the richness of darkly coloured shadows. You can also develop a rhythmic interplay of alternately changing values that give movement and direction to the overall design.

The qualities of surface texture on which the light plays help to develop the atmosphere of the subject and the surface interest of the drawing. For example, in the façade of a building under direct light, there is a juxtaposition of flat, opaque colour on, say, a colour-washed wall, against the busy complexity of reflected patterns on window glass. Frames, mouldings, tiles and organic elements such as shrubs or pot plants might contribute additional layers of colour and texture that all take the light slightly differently, according to their own materials and colours. These things, too, provide an opportunity for counterpointing the colour values to activate their relationships.

ATMOSPHERICS

The colourful effects of different kinds of natural illumination are combined with and modified by the atmospheric qualities of varying weather conditions. This is another area in which you are reliant on your perceptual skills and visual memory in devising a method of mark-making that can represent, for example, falling rain or snow, a dense mist or the shimmer of seaspray hanging in the air. There is continual change and motion, and with this, an apparent lack of substantial visual cues.

These are ambitious subjects to tackle in drawing. The vaporous and liquid qualities of such phenomena are perhaps more readily described with a fluid paint medium which allows a rapid technique. But to bring the problem into more familiar territory, consider that rain, mist and spray are, like light, all elements that are acting upon tangible forms and surfaces, things you can identify and convey. The problem is thus not so much how to "draw rain" as how to represent its effect on the colours and forms of a landscape or townscape.

Concentrate your analysis first on the kind of rain. Are you seeing heavy rain that seems to pass directionally across the fixed elements of the view or a fine drizzle or mist, which masks the definition of forms and "greys" the colours? Now think about drawn marks that might correspond to that visual sensation. Stippling, layered washes or finely drawn coloured scribbles might create the diffused, amorphous quality of

LEFT Studies of water by Elisabeth Harden show three very different technical approaches, each a successful interpretation of this challenging subject. A rippling surface effect is described with watercolour over wax; the strong colour contrasts of a high, curling breaker is developed in gouache and collage; a turbulent current is re-created by dense hatching with pencil point and brush tip.

ABOVE William Tillyer works with watercolour on a large scale to produce atmospheric landscape effects. The calligraphic image shows the fluid passage of the brush, laying in soft washes and hard lines of colour.

LEFT A pastel drawing by Judy Martin is based on the impression of a line of flowering trees seen in the distance, the colours more distinct than the forms.

form seen through mist or spray, whereas a more definitive, calligraphic style might capture the slanting fall of a heavy downpour. It could be effective to work in terms of an overall texture on the drawing surface, with a veil of active marks and no clear areas of flat colour.

It has to be said that this area of image-making is not easy, and many artists "solve" the problems by avoiding them altogether. But if you are interested in the challenge of atmospherics, do not be put off by the difficulties. Give yourself time to study the effects in relation to a familiar subject — such as the view from a window in your home and try out different ways of transmitting what you see through a variety of drawing media and techniques. In this way you have a good chance of arriving, either by accident or design, at a technical solution that corresponds to your perception. Drawing With Colour

Exterior light

When you seek to capture an effect of natural light, it is not usually possible to obtain all the information you need in a single period of concentrated drawing. Rather, you must train your eye to be alert to the cues of colour, tonal contrast and patterns of light and shade which are typical of a paticular time and place. If you make a number of rapid studies of a whole view or individual details, you build a body of reference work that subsequently can be used as the basis for constructing more complex and detailed drawings. At the same time, this process gives further opportunity to develop your visual and technical skills.

The main colour study in this sequence (far right) shows a garden view in afternoon light, with rich, strong colours under full sun and hardedged dark shadows cast from the standing objects. In the two smaller drawings of the plant pots, the artist investigates the different qualities of cool morning light, with pale tints and cool shadows, and the more intense light of evening in which the colours are all tinged with red and gold.

The smaller studies go into further detail of shadow patterns and colour values, trying out varied techniques of watercolour and coloured pencil drawing. You should always bear in mind how the medium and technique that you select can most aptly convey the qualities of your subject.

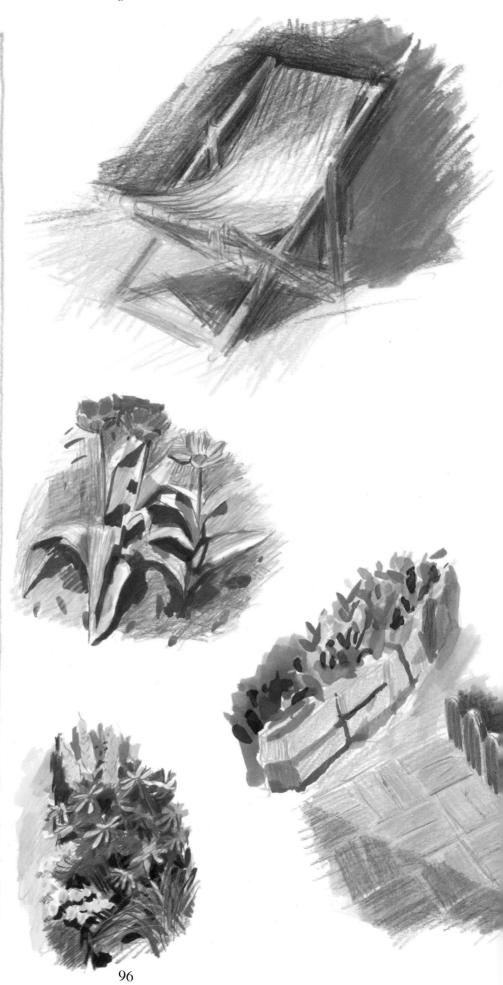

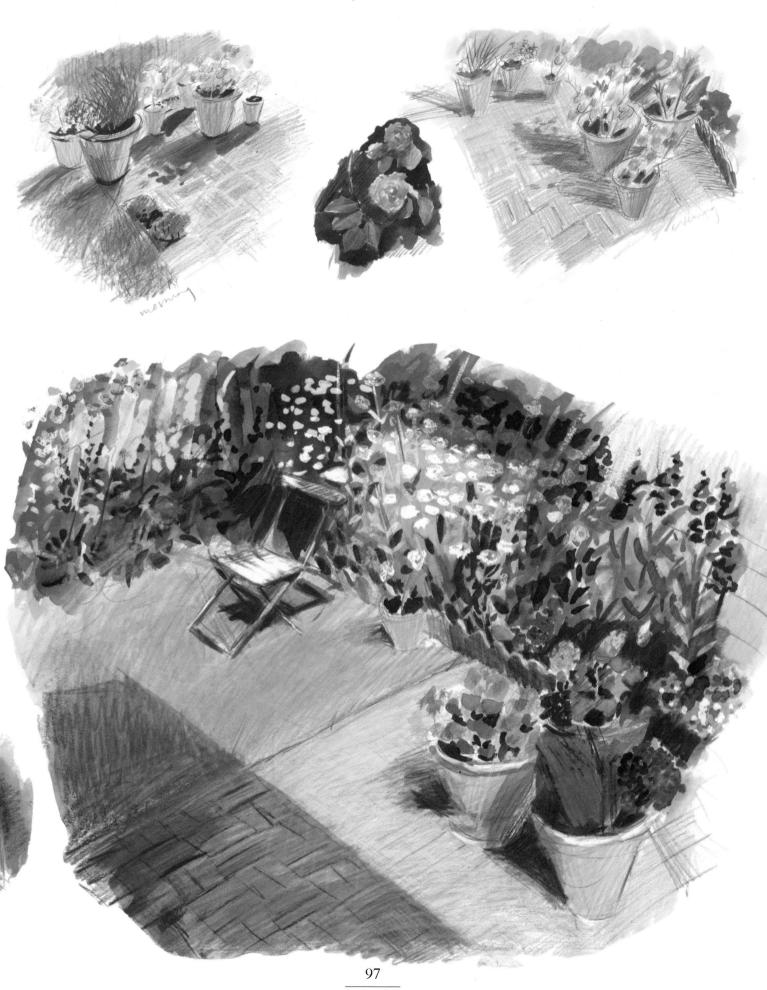

Drawing With Colour

ABOVE In her print of tulips, Ellen Gilbert mixes hatched lines with washed and textured colour. Careful evaluation of reflected colours in the tabletop provides an effect both decorative and highly descriptive.

BELOW Ian Simpson's watercolour study of a festively decorated interior has a subtle mood of wintry light. The colour key is restrained, keeping even the stronger accents of colour within a quietly atmospheric range.

INTERIOR LIGHT

In any outdoor scene, even in dull weather, there is a relatively strong level of light, whereas interiors have naturally lower light levels. We do not always perceive the dramatic change between indoor and outdoor illumination, as our eyes function perfectly well in the weaker light and we adapt quickly to the relative intensities.

Interiors provide, however, more variety of light and of visual mood, because of the varying qualities of the sources and the ways they occupy the space. On a bright summer's day in the morning, a room with large windows seems flooded with light, but by early evening, it is easy to see the contrast between the direct light from a window area and the much lower light level within the room. By night, the same space may be lit by a powerful central light source, or perhaps by small lamps making separate pools of light. The colours, tonal values and modelling of space and form within the room are seen very differently under each of these different conditions. Structuring The framework of interior architecture provides a well-defined compositional structure for a drawing. The flat planes and angled junctions of ceiling, walls and floor, together with solid furniture, shelving and other fundamentally geometric forms, create the basic "building blocks" of local colour that underpin the more complex effects

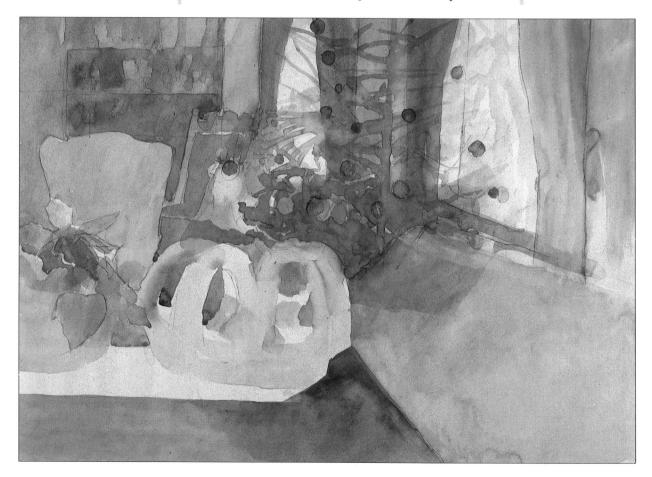

of colour and light. Within these blocks there are additional colour details in fabrics, pictures, books, plants, ornaments and so on, and all of these elements may provide a setting for a figure or figures.

Colour values contribute their own spatial emphasis to a controlled framework. As we have seen, cool or neutral values have an effect of greater distance than warm or brilliant hues, while high tonal contrasts are more structurally dynamic than close tonal relationships. These are aspects of colour interactions that you need to consider both in analysing your subject and in organizing the relationships within the drawing.

In an enclosed space the actual distances are small, and you may have the impression of seeing each part of the space with equal clarity, especially as you focus on particular features as you draw them. But this is an area where you must be selective, because if you treat each section of a drawing with the same sharp definition, intensity of colour and contrasts of tone, you may find that your drawing gives a confused sense of spatial relationships — the eye has no obvious clues about how to move around or into the image. You need to create a scale of relative values — in colour, tone and treatment of form — that indicates points of focus and the links between them, providing the emphases that explain the centres of interest you have found in the subject.

ABOVE In a second study of the same subject, the artist uses watercolour and coloured pencil to enhance the colour values of the lights and darks. Clear blues and purples offset the yellow patches of light, with the dogs strongly highlighted by splashes of opaque white laid over the drawn colour.

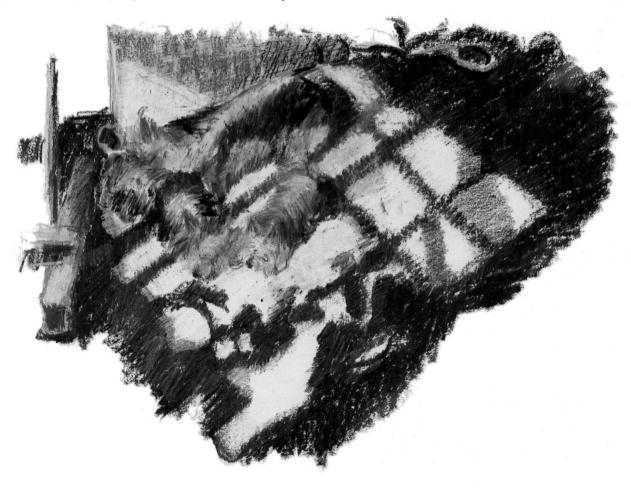

BELOW Daphne Casdagli uses heavy strokes of oil pastel to describe the cast shadow of a window frame forming a chequered pattern of light on the floor. Against the dark brown and purple shadows, she uses delicate streaks of yellow to enhance the highlights. The colour range is extended by the little dogs playing in the light on the floor, with contrasts of blue-grey where the light falls on their backs against the warm browns and yellows of the fur on their faces and undersides. The study makes an interesting semi-abstract composition from which the details gradually emerge. RIGHT Ashley Potter's colourful interior, in crayon on buff paper, gives an impression of strong light diffused through the room. Every colour accent is played up, creating a sense of space and atmosphere. The light from the windows is emphasized by, for example, the deep blue-purple shadow on the face of the figure at the left and also by the strong yellow and orange highlights on the chairs. The vivid colour in the foreground at right suggests a second light source, or possibly reflected light thrown back on to objects within the room from a direction near to the artist's viewpoint.

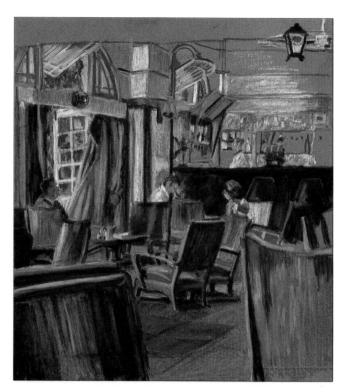

RIGHT The quality of intense, even light in Moira Clinch's pastel study comes both from the high-key, restricted colour range and from careful positioning of the highlights on the face of the figure, her hand, and the mixing bowl. Although these highlights are small touches, they play an important role in defining the atmosphere. Every aspect of pattern and texture has been exploited in the intricate brushwork. This makes the most of the colour range, employing the contrast of cool blues and bright yellows, and also knits together the surface of the image and the different elements within the composition.

The position, direction and strength of the light source are important cues in creating these focal areas, and can form the basis of visual interest and complexity in the drawn image. You may be particularly attracted by the simple arrangement of shapes and colours in an interior, but you must also consider the way the light acts upon these to create the atmosphere of the scene.

If the illumination is relatively bright and evenly spread, there will be fewer "depth cues", less abrupt variation across the range of colour and tonal values. For this reason, artists often choose lighting that provides a more obviously descriptive mood or contrive such an effect by adjusting the normal light levels. Another important factor is that sources of light — windows, a fireplace, a lamplit alcove — naturally form the focal points of an interior and you relate your impression of the whole space to such reference points.

Concentration of light The most atmospheric effects in interiors are created by having a single concentrated source of light — daylight entering through a window or door or a single lamp giving a more or less focused spread of illumination. Firelight or candlelight, although more difficult to represent effectively, contribute a distinct mood and colour-cast to the image. In purely practical terms, remember that if the main source of light is distanced from you, you will also need light to draw by so you will need to consider how this may affect the mood of the subject.

Daylight is usually a cooler kind of illumination than artificial lighting. The clear, brilliant yellows seen in shafts of sunlight are contrasted with blue, grey and sepia tones in shadows. The intensity of the highlights formed by reflection of strong natural light makes it difficult to assess colour, but where you see hints of colour, the amount of emphasis you give to them should be related to the colour values — or neutrality — of the shadow areas. The degree of contrast in light and shade depends on the concentration of light: wintry daylight filtering into a room has a generally lower key and more even tonal balance than strong summer sunshine.

Lamplight and firelight have a warmer character, sometimes even quite strong red and orange tints. Often the spread of concentrated light from such sources is quite limited, but there may be flickering hints of colour or soft, warm tones giving depth to the shadow areas. Variations of colour in light alter your perception of local colours, so you must carefully analyse the overall colour key of the subject.

The direction of a concentrated light source may act to emphasize or even radically change the modelling of form and volume. Sidelighting tends to give angularity to solid forms and intensifies the tonal contrasts that create an effect of volume. Light from overhead reduces the recessional depth of the pictorial space but may emphasize lateral space. A contained pool of lamplight can be used to "pull in" the spatial structure or to offset an impression of vast shadowy spaces surrounding the focal area. The lit shape of a door or window creates a layered framework, indicating the spaces beyond.

Such atmospheric detail works in conjunction with your angle of view into or through an interior. If a frontal view of

one wall dominates the compositional frame, the spatial sense is directly related to its apparent distance from you as observer. Angled views that take you into corners or alcoves give a more pronounced feeling of enclosure. A view through, showing a room beyond, a corridor or a door to the outside, progressively opens out the space.

Backlighting objects or figures within the interior by placing them in front of a window or lamp always creates a dramatic mood. You may lose interior detail, other than soft

LEFT Adrian George makes an effective tonal study in pastel which is alive with subtle colour accents. The solid darks are laid in with blended or slightly broken colour, then overlaid with vigorous hatching. The light tones are worked in the same way on the figure, but to define the plane of the window behind, the artist has built a complex network of criss-crossed marks in yellow, pale blue, white, pink and grey, which gives a startling quality of intense light, throwing the dark figure into relief. The pose of the figure throws the vertical stress of the composition slightly off-centre, and this is balanced by the horizontal detail of the decorative balcony rail, anchored by the heavy dark tone below.

haloing and contouring of the objects, but reducing the amount of visual detail can suggest a more intimate feeling, as it leaves more to the imagination of the viewer.

Shadow play In interiors, as in landscape, cast shadows can provide particular interest. They can divide up the picture space between light and dark tones, create an alternative rhythm of new shapes or throw a more complex variety into the modelling of solid forms. Shadows may contribute counterbalances of weight and direction in the colour relationships or simply create a decorative effect of patterning.

A very basic but surprisingly effective form of shadow is the grid-like pattern of a window frame running at a distorted angle on the floor where the shadow is cast by natural light from outside the window. This idea of using shadow to set up alternative movement and direction within the framework of the composition can be elaborated if there are such elements as trailing pot plants at the window, a slatted blind or boldly figured lace curtain. These things create linear pattern elements and also an interesting tonal counterpoint of rapid changes between light and dark areas.

Concentrated sources of artificial light throw shadows onto walls and floor, echoing the shapes of solid objects within

the room. A similar and more complex effect comes from cast shadows falling from one object onto another. This complicates the interactions of shapes and colour values, sometimes giving more emphasis to repeated shapes and sometimes disguising the reality of the subject by the almost arbitrary relationships between cast shadows and the tonal gradations that model form.

It is natural to think of such effects of light and shade broadly in terms of tonal rather than colour values. To produce a drawing that is alive to the colour potential of such a subject, you must remember to look for the colour accents and influences and relate your drawing techniques and choice of materials to the development of these elements.

Windows When you look at a view through a window, are you conscious of the window glass? Do you notice it as a material plane, or do you ignore its substance, as if it were simply a hole through the wall that enables you to see the outside world? It is most likely that you only take account of the window pane as a thing in itself when it reacts with some other element — raindrops on the glass or reflections thrown back into the room at night. More prosaically, you notice the glass if it needs cleaning because it interferes with the view.

RIGHT In this pastel drawing by Judith Rothchild, the window framing the central subject is treated as a reflective plane. All the colour detail applied to the window glass corresponds to elements reflected from the interior, shaded into dark tones which allow no hint of what is beyond the glass. This focuses the main layer of visual interest in the lower half of the picture, where the brightly highlighted strawberry tarts are more dimly lit in their reflection, but this secondary image is still drawn in some detail. The colour values contribute to the focus, with the emphasis on reds and pinks in the foreground against the green accents on the window glass, but these two elements are linked by the inclusion of purple and blues, making a subtle transition through the whole image.

If you are drawing the view from your window because that is the most convenient way to study it, there is no need to remind yourself that you are looking through a vertical plane with a physical presence. But if you are making an interior drawing which incorporates a window and part of the view outside, you might wish somehow to signal the division between interior and exterior space. One conventional way of dealing with this is to make the outside elements more muted in colour and less clearly defined in form than those inside. Or, if there are areas of reflected light on the glass, these can be treated as areas of almost solid tone and colour that are played off against the colours and shapes of objects seen through the window pane.

There are other more complex visual effects that come from different kinds of glass in windows and doors. Most window glass, which is not meant to obstruct vision, allows a clear view, but there are also textured forms of glass, such as those used in interior doors, kitchens or bathrooms, which are translucent, designed to transmit light between interior spaces but also to provide a degree of privacy. These can be interesting elements in a drawing, as the effect of textured glass is usually to create a mosaic of colour and tone that is composed partly of what is seen through the glass, partly of light and colour reflecting from it.

Translucent fabrics, such as muslin or net, reflect light in the sense of having a distinct presence of their own, but do not create obtrusively colourful surface detail. A fine curtain partially drawn across a window creates an effective pictorial contrast between soft tonal gradations in the fabric and the hints of colour seen through them, as compared to the relative clarity of the window view and the solidity of neighbouring objects. The same is true of light fabrics used as drapery or clothing — they provide surface colour values which model their own folds and hollows, and tonal changes echoing the forms beneath, but these are also subtly modulated by underlying colour influences.

Interior light

As compared to outdoor light, the light sources within an interior are more readily controlled by the artist, although it is often a chance effect of daylight entering a room that provides the idea for an effective composition. However, there can be great variety in the colour quality and intensity of the light, depending on whether it comes from a natural or artificial source.

Whereas you may have strong natural light at a window, the level falls quickly further into the room. In two studies here (far right), the artist describes the brilliant light from a large window complemented by a smaller pool of lamplight focused on the shadowed work area. These provide interesting patterns of light and shade enhanced in one case by the central focus of the window frame, in the other by the slatted blind drawn down over the window.

Smaller studies (top right) deal with the enclosing effect of concentrated lamplight, which draws in the space of the room and creates a warm glow. This effect has been interpreted in loose watercolour washes overlaid with crayon and pencil work, and in a coloured pencil rendering with an atmospheric, grainy texture.

The linear pattern of the louvred blind is exploited in the third small study (bottom right) and its effect in highlighting the objects standing in front of the window.

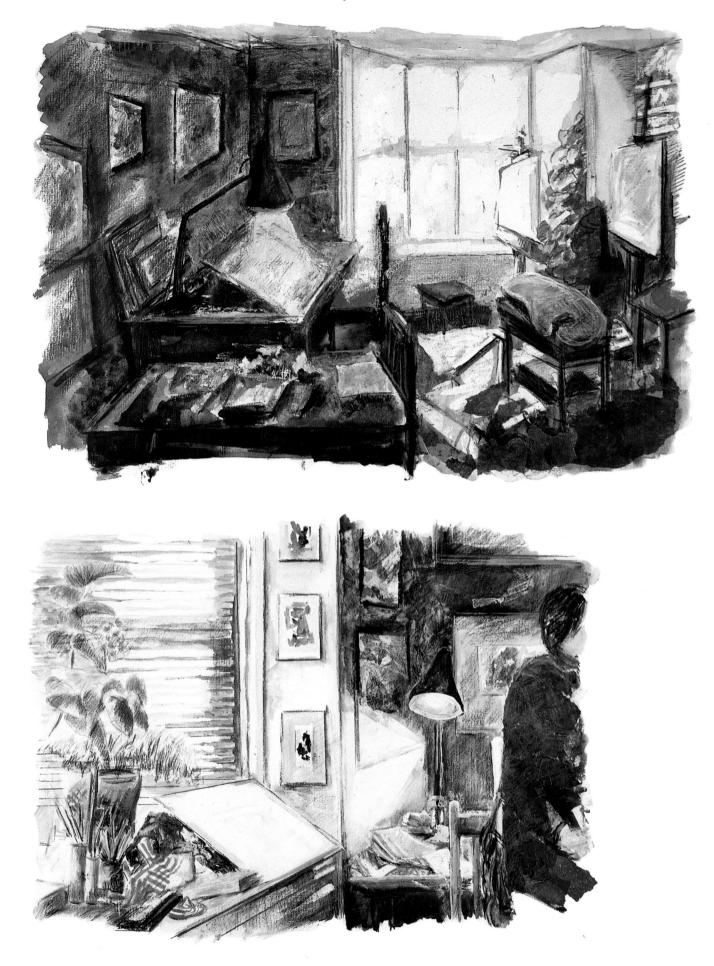

Expressive Colour

LEFT A watercolour portrait study by Graham Dean combines the expressive pose of the subject with vivid colour treatment emphasizing the mood. The technique appears loose, but it requires careful control to build the colour strengths and descriptive textured effects of merged and diffusing hues. If you look at the life's work of almost any major artist, you see similar themes and subjects recurring through the years. Pictorial themes are continually reworked, with different developments of shapes, forms and colours — sometimes with only minimal changes, but sometimes with a dramatic leap of artistic invention. This is the clearest demonstration of the threads that link personal responses to real sensations and the means of expressing them. This kind of reworking is a gradual investigation of all the visual possibilities, which finally become familiar properties, allowing the artist to select the ingredients of a personal style.

Many children can draw with an easy disregard for reality that creates a vividly personalized "other world". With growing experience of the real world, that spontaneity and confidence are commonly replaced by an anxiety about "getting it right". It takes time and discipline to gain the experience of drawing that allays that anxiety, but once there is a basic confidence about drawing reasonably well and BELOW A delightful and deceptively simple image by Debbie Mason, actually requiring a steady and confident hand to achieve the fluid line quality and composed interaction of the lizard shapes. Such apparent simplification of a recognizable form must capture an essential quality of the subject.

fluently, there may also come a sense that there is somewhere else to go, something else to say through drawing.

The emphasis of this chapter is on going beyond the basic disciplines of objective drawing to develop a more individualistic form of expression. It is not a matter of forgetting what you have learned, but of building on your existing knowledge to add an extra dimension. Colour is an especially vital element of self-expression, having the potential for varying moods and emotions, for suggesting movement and activity, for tempting the viewer to respond directly to an LEFT Moira Clinch's pastel study of flamingos is based on naturalistic colour, but plays up the variety of hues — the pale mauve shadows and bright yellow beaks, for example — to develop the complex network of shapes formed by the birds' intertwining bodies and necks. The pastel strokes follow through the rhythm of the composition, and this is enhanced by allowing the top of the image to stand free against a white ground. This contrasts, too, with the treatment of the lower area, where faceted blocks of colour convey the reflective surface of the flamingo pool image rather than stand back and observe. This potential is always present; the artist's task is to draw it out by intervening between subject and image to make a more significant "translation" of visual impressions.

INTERPRETING COLOUR

"How do you see this tree? Is it really green? Use green then, the most beautiful green on your palette. And that shadow, rather blue? Don't be afraid to make it as blue as possible." This remark, attributed to Paul Gauguin, was astonishingly bold for its time. Even now we can appreciate it as an encouragement to release the sensations of colour from strict boundaries of "realism". It is also important to understand that Gauguin was not endorsing a purely abstract use of colour, but suggesting that a different kind of realism was to be found through artists allowing their perceptions of colour to be felt and expressed uninhibitedly. The tree is green, the shadow is blue, so the depiction Gauguin advocated was to an extent based on an objective response.

ABOVE AND BELOW One way of developing a more expressive colour approach is to try out different interpretations of the same subject. Selfportraits make use of a conveniently available model. A series of sketches by Judy Martin investigates variations of mood in line, using felt-tip pens and markers, and in shaded colour applied with coloured pencils.

ABOVE A portrait study in ink and watercolour by Ian Ribbons makes a disturbing image by avoiding reference to naturalistic colour. The nervously active line drawing is fleshed out with a complex network of brushmarks. As a method for developing a personally expressive approach to colour work, this is a useful model. It is a way of putting yourself and your responses to colour into your drawing without going so far as inventing a personalized language of colour. It provides the opportunity to allow yourself a bold statement that has a referential framework. You can find what interests you most about a subject and focus on that element, then exaggerate it. This principle can be applied to all the different aspects of colour already discussed so far—the relationships of pure hues and tonal values, colour accents, surface detail and the colour key of your drawing.

All drawing is a contrivance—if your only purpose was to reproduce a picture of a subject, you could simply take a colour photograph. It is the choices and interventions that have to be made in translating real objects into a drawn image that motivate the activity. There are, however, degrees of objectivity; also within your range of decisions about picture-making are methods of deliberate manipulation that, in giving mood, drama or emphasis to a pictorial image, represent the particular kind of reality which you have seen in the subject.

Adjusting the balance The colours and tones in a drawing give body to the structure of the image. In representational

ABOVE This drawing of roses by Judy Martin was begun in pastel, exaggerating colour accents such as the blue shadows and experimenting with converting the delicacy of the real flowers into a more vigorous image relying on heavy strokes of colour. Once the general impression of the subject was laid in, the forms of the petals were retraced in felt-tip pen, using a bright red to strengthen the colour contrasts and sharpen the focus of the image.

ABOVE A colour sketch of a fallen tree in pencil, gouache and watercolour, catches the strong balance of form and colour by emphasizing tonal contrast but also introducing many subtle colour accents. Working on a neutral-toned paper, Kate Gwynn gradually develops the range of hue and tone, using the buff background tone and application of neutral greys as a foil for strong touches of colour, such as the vivid light mauve interspersed with greens and yellows through foreground and background. The bold use of pure black gives the image structure and impact. work you are most concerned with how the real colour values contribute to the illusion of form and space, with identifying and recording them in what appears to be a "correct" relation. At a certain point, however, your attention is also taken by the internal dynamics of the drawing and how it works within specific parameters. A drawing is a record of something you have seen and of the process by which you have described it. You may find that you want to focus more on working up the balance of the image in its own terms, if necessary allowing it to become somewhat detached from its model in the real world so that it can be developed more strongly in terms of the drawing processes.

This may involve adjusting the emphasis of both the colour values and the gestural quality of the marks you have used to convey those values. Take as an example a subject that has a basic solidity and static form and a naturally controlled colour key, such as a townscape view containing blocks of neutral colour and relatively muted hues. You may render this quite faithfully in terms of what you see, but then find that the drawing is lacking in some way — perhaps it fails to catch some quality of light or colour accent that would give it more life. You then need to study it more closely to see whether there are hints of colour that could be played up, whether the

ABOVE This simple symmetrical image isolates the form of a flowering tree and reinterprets its colourful effect in terms of abstract dabs and dashes of bright gouache colour. Judy Martin later developed this idea into a series of fully abstract paintings.

apparent "flatness" of walls, streets and sidewalks could be given some internal activity, perhaps simply in terms of a more vigorous approach to mark-making within the drawing. Adjusting the balance of line and mass may activate the image, especially if the colour stresses are rhythmically linked between the two elements. It is possible to give quite strong emphasis to such surface qualities in a drawing without losing the coherent sense of structure that is also a crucial part of such a subject.

Adjusting the balance of colour and tonal values may also provide a more dynamic overall impression of the subject. A drawing that turns out rather flat — a still life that loses the distinctiveness of the forms or a landscape without sufficient sense of distance — might be enlivened by alterations to the tonal key. Perhaps the darks need to be made darker, the highlights more vivid; or perhaps the middle register of tonal values needs more definition and contrast. Alternatively, you might find that a more dramatic mood is created by limiting the colour values, by making a very strong statement using a RIGHT An abstracted landscape in mixed media by Vincent Milne spreads a dominant block of yellow over more than half of the picture area. The slanted horizon line gives subtlety to a basically simple composition and the heavy paint and pastel textures activate the surface.

BELOW Kate Gwynn takes a calculated risk in slashing the vivid red of the glider wings right across the width of the image, but this is a successful contrast to the muted, dense colours of the landscape below.

BELOW A gouache figure study by Stan

falling through a slatted blind as a semi-

abstract pattern of pale tone across the

shadowy form and interior. The two

elements work together because both are

loosely defined, developing the mood of

the image rather than its descriptive

aspects.

Smith uses the strong shafts of light

112

restricted colour range that complements the subject.

Dominant colour A powerful effect of colour intensity comes from allowing a single colour to dominate the drawing. There is a natural "overbalance" of colour type in some subjects — greens in landscape being perhaps the most obvious example. In an interior, warm reds, yellows or oranges or, alternatively, cooler blue and purple hues may occur due to the lower light levels and the particular quality of a natural or artificial light source. These naturally created colour biases help to set the mood or key of an image.

The idea of allowing one colour to dominate has been exploited by artists from Van Gogh onwards to produce both expressionistic and abstracted imagery. There are ways of using close tonal values and strong colour intensity that redefine the sense of form. In a drawing with a contained sense of space, such as a small interior or a figure study, the sense of closeness created by the broad spread of a single, dense colour value can contribute particularly effectively to the interpretation of the subject.

This approach can be exploited with any colour by selecting a few closely matched tones. Using a wider variety of

hues and tonal values of a single colour, or a couple of related colours, you can create more emphatic modelling and play up qualities of light and shade while maintaining an overall colour character.

There are two main ways of employing a dominant colour. One is to block in solid areas of close-toned colour values to form the basic ground of the image, and the other is to interweave lots of hues and tones of the same colour family to create a very busy surface texture that reads as solid form. A good way of trying out the effect of a composition expressed in terms of a single dominant colour is to choose a piece of strongly coloured paper and work mainly with line and calligraphic linear marks, in colour, to sketch in basic detail of contours, highlights and deep shadows. Apply this technique to picking out essentials of form and definition, allowing the colour of the paper to hold the main balance of the image. This will give an overall impression of the colour balance without requiring a lot of time-consuming work in building a coloured ground with drawing materials. You can use scraps of paper to create colour thumbnail sketches, too, to try the different effect of each colour selected from a given range.

Life studies

Drawing the human figure has been a basic discipline of art training for centuries and is still regarded as a uniquely important skill. No other single subject presents such complexity of form and surface. The life model provides a versatile structure — a simple change of pose confronts the artist with a completely new set of relationships of form, light and shade, surface texture, and colour values.

Perhaps because of the academic associations, students do not always find it easy to discover something new and exciting in life drawing. These examples show how colour can give a startling new vitality to this established discipline, and a fresh modern character to the resulting images.

There are two basic approaches to life drawing in colour. One is to select a colour range that can be used as an equivalent for the tonal scale. In this way, the figure is "modelled" with light and shade in the traditional manner, but using colour relationships. Alternatively, existing hints of colour in the flesh tones and lights and shades can be pulled out and emphasized, developing expressive colour interactions. A strong paper colour helps you to make an emphatic visual statement.

The standing and reclining figures also display a remarkably sensitive quality of line drawing that derives quite naturally from the fluid contours of the human body.

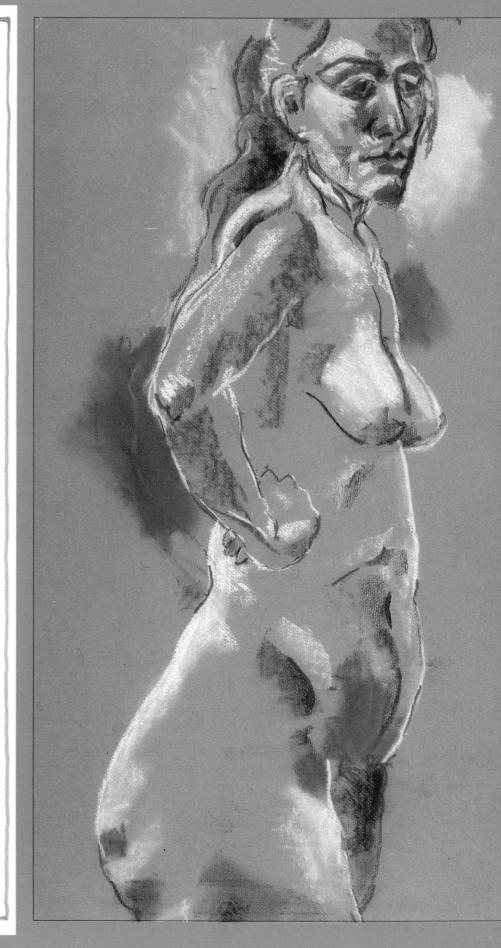

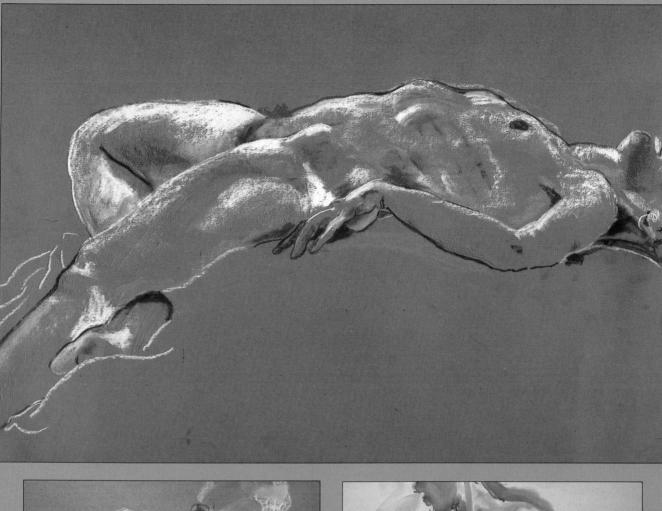

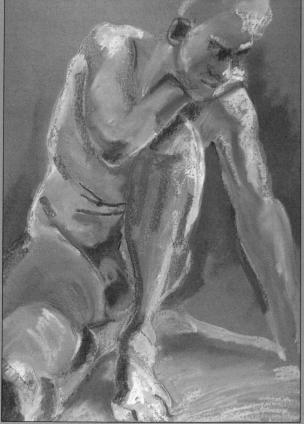

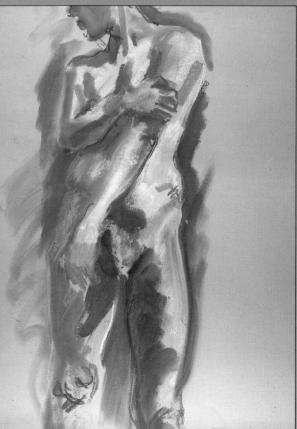

HARMONY, CONTRAST AND DISCORD

As you gain experience of colour interactions, you may wish to manipulate the relationships to give more emphasis to the effects of harmony or contrast. Look back to the colour wheel on page 23 and identify the harmonies between adjacent colours on the wheel and the tonal variations within individual hues. You will also be able to see the potential for clashes and contrasts between colours that are not similar in hue or tone. Thinking of the abstract relationships of colours may stimulate ideas for stressing different aspects of their interacABOVE Natural subjects such as fruit and flowers invariably contain their own colour harmonies. In assembling a still life, the artist can choose to extend or counterpoint the natural colour range. Jane Strother makes a strong composition by contrasting the warm, pale colour of the grapes with rich dark tones.

LEFT Marian Carrigan creates an unusual scheme of colour in this busily patterned image. It reverses a conventional approach by putting the strongest hues within the central mirror image. The surrounding colour ground also does the unexpected in that the yellow has a dark tone which makes it almost equal in value to the subtle blues, an adjustment of the typical relationship between these colours since yellow is usually among the palest tones.

tions that will increase the harmonies or develop colour tensions in your drawings.

It is also useful to look at paintings and at the colour schemes and combinations in designed objects, such as fabrics and ceramics. These provide information about other people's experiences of colour relationships and the ways they have used them to demonstrate the physical, decorative and abstract properties of colour. Because these are finished statements, contrived to answer the requirements of a particular context, they are directly instructive. You should not feel hesitant about borrowing someone else's solution if you can make it work for you in specific terms. Remember, however, that the artist has put deliberate thought and intention into creating his or her own colour expression, and this deserves a thoughtful response, which will enable you to decide how that experience may serve your own intentions.

Natural colour schemes are a valuable source of interesting and sometimes unexpected colour combinations—the muted hues of weathered stonework, the brilliant variations of colour in garden plants and flowers, the related moods of landscape and sky showing peculiar luminosities and tonal contrasts. You will probably use these elements to describe the objects themselves, but you can also extract from them a more

ABOVE AND LEFT The relationship of colours within a composition can significantly alter the balance of the image, and is itself dependent on the quality of colour and texture in the drawing medium. Quick pastel sketches are used here to try out varied densities of colour and tone in a simple still life.

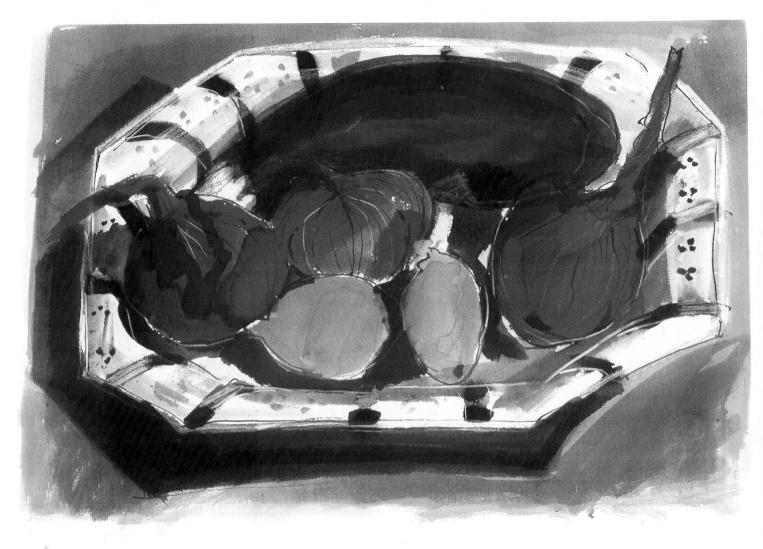

general sense of colour relationships that can be adapted to other subjects. In this way you will introduce a lively sense of invention, but one that still has a basis in reality.

We tend to seek harmony almost instinctively; the relationships of pure hues and the balance of lights and darks are elements we naturally wish to organize harmoniously. In drawing, we do this by making links between colours in different areas of the picture; by using a line of pure colour to balance a heavy mass of colour and tone; by shading blues into blue-greens, yellows into oranges, softening any harsh edges between unrelated tones and colours. We can also see, though, how strong, well-defined touches of contrast can emphasize the more fluid gradations of colour and tone, and this is a way of devising a balance that creates harmony.

It is surprisingly difficult to strike a discordant note in colour work, not only because our instinct is to create a pleasing balance, but also because we are very tolerant of even quite extreme interactions within unusual colour combinations. The world is very colourful, and much of the colour information we absorb daily, almost without thought, is designed to be eye-catching and stimulating — particularly in consumer packaging, advertising and media design. This has given us a sophisticated familiarity with colour that subtly acts upon our own approaches to using it in image-making. There is also a purely subjective aspect to colour preferences, one person's idea of a harmonious combination of colours sometimes seeming strange and unpleasing to another.

The concept of discordant colour therefore lies more in trying to strike an unexpected note in a given context than in identifying forms of colour behaviour that would create a sense of harshness or unease. Reversing tonal values is one such possibility — a brilliant light value in purple shadow on a rich dark red, for example, or tiny touches of intense mid-blue enhancing the brilliance of warm golds and yellows in a mixed hue. Notice, too, that these examples introduce the interplay of warm and cool colours. This could be employed in the purple-red contrast by setting a pale blue-purple against vermilion, but also by playing a light mauve-pink against a cold bluish-red.

The texture and shape of the drawn marks also contribute to the type of colour interaction that a combination of individual hues will seem to make. If you place a vivid scribble Expressive Colour

LEFT Jane Strother makes the most of rich colours in a vegetable still life. She relies on contour to indicate form, allowing the colours to flood freely across the shapes. of one colour on a flat ground of another colour, the effect is slightly different according to whether you use a fluid, curving motion or a jagged, broken line. Similarly, the quantity of one colour against another has an influence. Try, for example, making the curved or jagged scribbles first in a pale colour on a dark ground, then in the reverse colour relation. Such elements are components of a descriptive mood, affecting our sensations of colour values.

CREATING A MOOD

Many of the projects and examples of finished drawings illustrated in previous chapters have included a sense of mood and atmosphere, as well as conveying the more straightforwardly descriptive qualities of the subject. This demonstrates that the mood of an image is not a separate element to be integrated with the form of the composition, but is already potentially there in each aspect of the colour work in a drawing. A relatively simple way to create a sense of drama is to exaggerate the inherent qualities of an ordinary scene by heightening tonal contrasts, intensifying colour values, giving some shapes and forms a more powerful presence than others. Any such methods of creating an unexpected imbalance in the weights, textures and rhythms of the drawing seize the viewer's attention in a way that a harmonious and completely balanced image does not.

It is worthwhile pointing out the obvious here — that certain subjects have a particularly striking mood or atmosphere that any successful drawing must convey. A street ABOVE The colours of oil pastels are typically bright and strong. In an impressionistic sketch of a street scene, Tom Robb gives each colour its full value, creating a vivid interaction.

ABOVE A portrait study by Ian Ribbons evolves out of densely scribbled pastel strokes in which the colours are played over a warm-toned paper. Both the technical approach and the colour balance are designed to give character to the portrait.

RIGHT Sally Strand allows the mood of her chosen subject to speak for itself, by focusing on the undisturbed selfabsorption of a mother and her sleeping child. The gentle atmosphere is enhanced by depicting both faces in shadow against the strong summery light woven across the flesh tones and beachwear of the figures.

ABOVE By contrast, Ian Ribbons's watercolour sketch of a violinist while loosely worked, expresses a calmer mood in the more ordered brushwork and low-key colouring.

Expressive Colour

market, for example, is a colourful and active subject, so there is no point in trying to devise a way of representing it more subtly. But you might choose to play up the activity by, for example, stressing the vividness of the colour relationships and allowing free rein to the calligraphic qualities of your drawing technique. There are also occasions when you might wish to counterpoint the mood that a subject seems to suggest by altering its emphasis. An open landscape, for example, generally has a peaceable atmosphere, but if you were to depict it with a deep blue-grey sky threatening stormy weather instead of a clear, sunny one the whole scene would have a quite different mood.

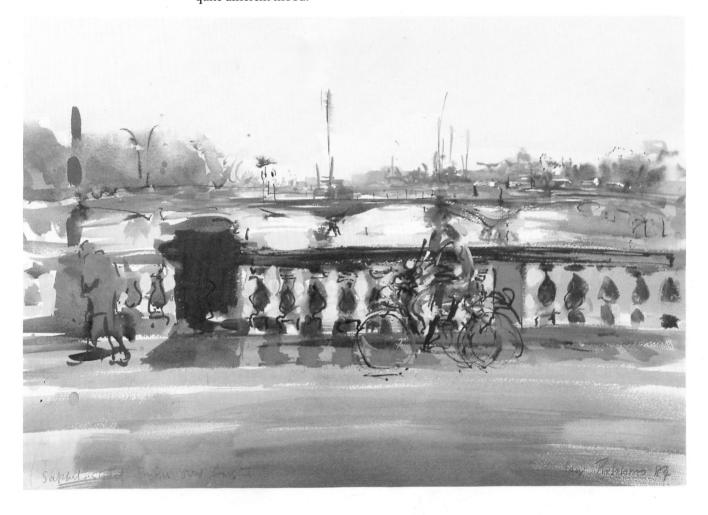

Qualities of mood are also rather subjective, and no single colour quality or technique works in only one particular way. Active mark-making, such as hatching or scribbling, will in one context enhance the energy conveyed by the subject, but in a different context may create a relatively coherent surface texture. The following are some general principles and suggestions for developing mood and atmosphere in colour drawing, but take time also to study the illustrations throughout this book and analyse how the mood of any ABOVE There is a tranquil mood to this watercolour sketch by Ian Ribbons, deriving partly from the gentle colour influences conveying clear light, partly from the frontal view of the subject which makes the main axis of the composition divide the image area horizontally.

particular image is made to work in terms of overall composition, the colour detail and the drawing technique.

Colour intensity Pure hues with high colour intensity have an exciting, active visual quality. This has been notably used in expressionistic styles of drawing and painting, where strong colour values are often emphasized to create a more emotive image. In a portrait or figure drawing, for example, playing up the accents of strong colour creates a more aggressive or dynamic representation than a naturalistic rendering of subtle flesh tints and hints of reflected colour.

Warm and cool contrasts Warm colours tend to have more vitality and seem nearer to the viewer than cool colours, which by comparison are passive and recessive. As in the open spatial quality of landscape, blues and greens in an interior view are less enveloping than hot reds and oranges. Remember, however, that these are relative colour qualities and dependent on the interactions of hues and tones.

Colour keys High-key schemes of colour can suggest a cheerful or expansive mood. Low-key treatments more suitably correspond to a sober, melancholic or threatening atmosphere. This aspect of colour moods is particularly related to colour intensity and the degree of tonal contrast. The

BELOW David Bomberg's pastel radiates shimmering light, the sense of form and space emerging subtly from the masses of grainy colour. The mood and tone are set by the warm colour of the paper, the pastel work maintaining a high key overall.

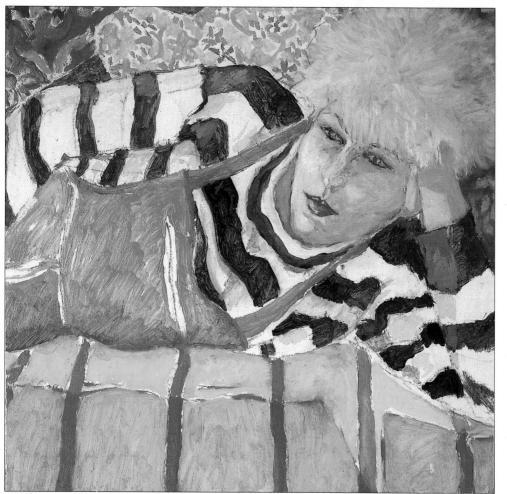

LEFT Marian Carrigan develops a strongly expressive portrait with colours that almost escape into garishness, but she controls the values quite precisely and uses the pattern elements of the composition to form colour links throughout the image. The face is modelled with high tones even in the shadows, the vivid yellow of the highlighting counterpointed by a cold pale blue that describes shaded form and cast shadow as effectively as would a darker-toned colour. But the artist reserves strong tonal contrast for the bold stripes of the sweater, again highlighted with pure yellows.

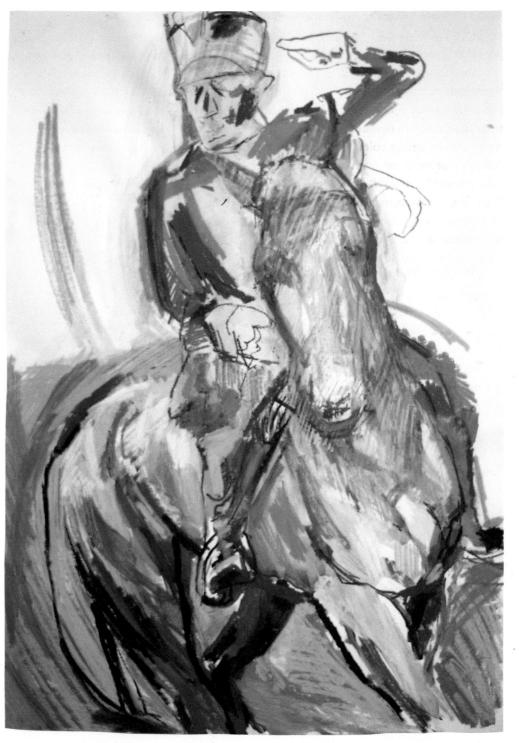

LEFT Colour drawing is a new departure for Linda Kitson, whose well-established reputation for draughtsmanship has been built on her skill in drawing with line. Her sensitivity to the rhythms and contours of a subject is here expressed in strong mid-toned colours, with energetic brushwork creating form and movement.

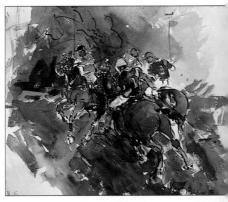

ABOVE Ian Ribbons chooses a sombre palette for his ink and watercolour sketch of polo players. The turbulence of the action is expressed through vigorous line work overlaid with loosely brushed colour. The dark tones concentrate the focus of the image around the knot of horsemen.

inertia of some dense pure hues or dark values of particular colours can give a comfortable sense of quietness to a low-key colour range where these values predominate.

Tonal contrast The different ways of emphasizing tonal contrast to create mood depend upon relative areas of light and dark values. You can develop a mysterious mood by suffusing a drawing with darkness, offset against a single focal area of light, such as a window, lamp or open door. In this context, shadow areas can be made richly colourful because they play a

major role. Or you can weave a complex pattern of light and shade which suggests a particular time of day or a languid or active mood. Cast shadows creating a linear pattern need to be carefully looked at for the edge qualities between tonal changes, the definition of interlocking shapes and the relative colour values.

Surface qualities Both the colour relationships and the physical quality of drawn marks activate the surface area of a drawing. Bright colours and vigorous linear drawing have a

BELOW Sometimes it is in the pose and framing of the subject that the artist most strongly expresses the mood, the colour work complementing the narrative content. This is the case in this watercolour and coloured pencil portrait by Derek Brazell and the colour work, with its warm light and soft, deep shadows is perfectly keyed to the quiet mood of the image. more dynamic presence than softly gradated shading of blended hues. These elements can be manipulated to enhance a "loud" or "quiet" atmosphere, developing the sense of energy and aggression or gentle calm in the overall mood.

Points of reference Focal points are created in terms of both the compositional structure of the drawing and the particular areas of interest within the subject. An accent or patch of strong colour among neutral or dark ones naturally draws the eye. In a similar way, a figure within an interior or landscape is a point of identification for the viewer. These two aspects of image-making can be made to work together, for instance by giving the figure the most colourful presence in the drawing or by setting up an intriguing opposition, possibly interpreting the figure as a shadowy half-lit presence.

RIGHT The natural world provides the colour cues for this vivid flower study by Jean-Marie Toulgouat, and the artist gives each hue its full impact, creating a language of pattern that corresponds to the impression of the massed flower colours. The image is based on reality but also worked out freely in terms of the material qualities of the medium.

ABOVE Non-naturalistic colour is used in these brief felt-tip pen sketches to note down the patterns of the urban landscape. As long as the colour is related to structure — form, light and shade the image remains based in a real visual logic which makes it easier to develop pure colour values expressively.

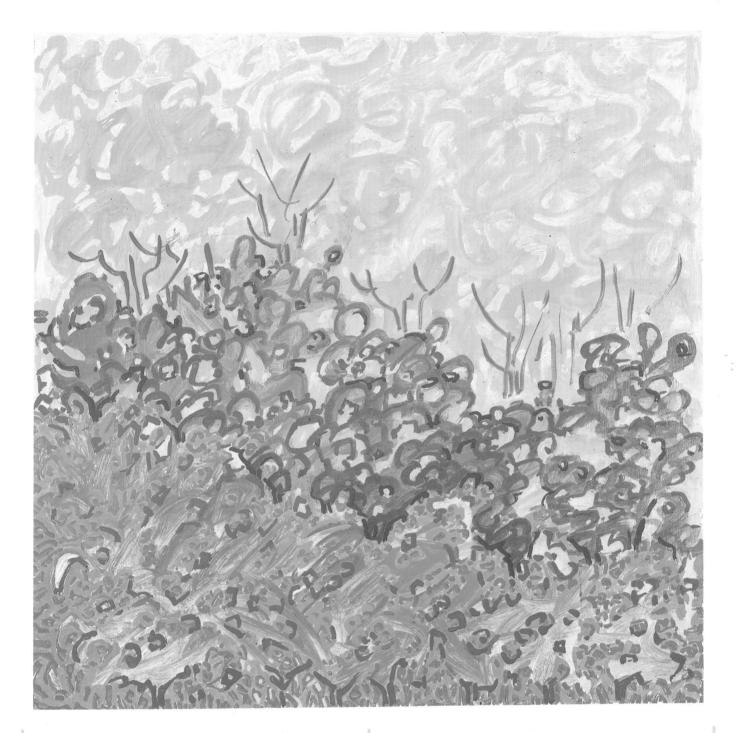

Testing sensations You can establish ways of conveying different moods in a subject by making a series of sketches or quick drawings. In these, you can make adjustments to the colour key, tonal relationships and compositional balance of the image, also using different drawing techniques to suit the impression you want to create. As this is a basically interpretive area of drawing, it is not always necessary to work from the subject itself. You might wish to investigate several potentially different moods in a subject you have already successfully captured in one way in a finished drawing. This is an area where the perceptual skills developed from objective

study can be extended independently in terms of your experience of drawing and colour interaction.

NON-OBJECTIVE COLOUR

Once you have experience of working with colour and have understood the capabilities of your materials and techniques, there is no reason why you should always work within a frame of reference originally based on local colour. It can be exciting to try out "unreal" colours, but related to real form.

A way of investigating this more abstract use of colour is to maintain the basic structure of the composition and apply

ABOVE AND RIGHT These cat studies by Judy Martin investigate different ways of describing the form with colour. Both examples on this page rely on the contour, first using charcoal and acrylics to describe the massed shape of the body (above), then using a monoprint technique to sketch in overlaid layers of textured colour (right).

colour in strictly pictorial terms. You might, for example, choose to use pure colour values to differentiate particular elements — vertical and horizontal surfaces, shadows and highlights, solid forms and the spaces between them. Your experience of colour can be used to create an effective orchestration of colour relationships, in terms of hue, intensity and tonal value, that gives the drawing subtlety and coherence. The general principle of tying colour values to the structures of form and space, though no longer in the "real" terms of local colours and tones, enables you to develop a logic of picture-making — without this the result could be a disastrous confusion.

Since there is no precise model for the final image, this may be a hit and miss affair at first, producing as many failures as successes. But, as with any drawing process, once you have gained experience of how to make the component elements convey your intentions, you will gradually acquire the skill to make the image work in its own terms.

DECORATIVE COLOUR

Colour is decorative — that is one of its proper functions, and one that is responsible for a large part of our pleasure in using it. In art, however, the idea of decoration is sometimes equated with frivolity, a "not quite serious" approach to creative activity. But colour is a generous element touching on all human experiences, and there seems no need to dismiss any of the different roles that it can play or to create a hierarchy of creative values.

This part of the chapter looks at a different aspect of working with colour that has not so far been stressed. The qualities of colour patterning have been described in relation to colour accents, effects of light and shade and the variety of surface elements that form a balance in a composition, but here we look at the decorative effects of pattern and texture as creative elements.

Black, white, colour The colours of stained glass gain their particular brilliance from the light passing through the glass, but the vivid effects of individual colours are also enhanced by the black tracery that forms the linear design of a stained-glass window. In drawing, black outlines around patches of colour serve a similar function of isolating and offsetting pure hues.

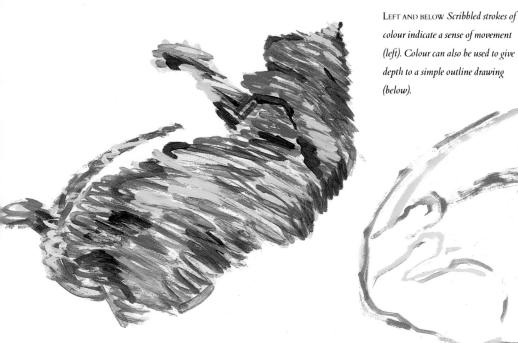

A comparable effect comes, perhaps surprisingly, from forming the outline by drawing "negatively", leaving a white line travelling through the image to define the shapes. This technique is called anti-cerne *(cerner* being a French verb meaning "to encircle"). It appears in certain paintings by Matisse, the coloured shapes being separated by lines of bare

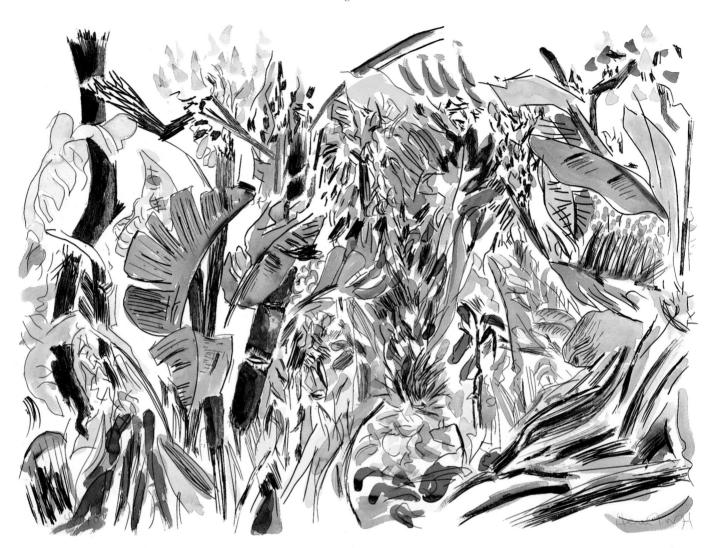

ABOVE A black keyline can give colours a particular clarity, traditionally exploited in line and wash techniques. In this tropical image by Michael Heindorff, the line work is etched, having the strong fluid quality and textural variation typical of this medium, and the resulting print is hand-coloured with watercolour washes. The white space travelling in and around the line and colour also helps to activate the colour relationships and the impressions of form and pattern. canvas. In the same way white outlines in a drawing can be created by leaving the paper surface uncoloured between the shapes. Alternatively, you can use the "white line technique" of impressing lines into the drawing paper by placing another paper layer over it and tracing the design firmly with a pointed tool. When you then shade with a coloured pencil or crayon over the original sheet, the impressed lines show white through the colour layer. This creates a relatively delicate effect, so it is not suitable if you need strong outlines.

Surface pattern and texture Patterns often occur in our surroundings as an accidental by-product of a function — as in the geometric arrangements of brickwork, roof tiles, fence posts and other such constructions. But things that are patterned rather than those that form patterns are usually purpose-designed to be decorative — dress and furnishing fabrics, rugs and carpets, wallpapers, and so on.

Textures, on the other hand, are inherent surface qualities; they are not applied in the way that patterns are. In some materials, a colour pattern is naturally integrated with the texture — marble veining or wood grain for example. Other materials, such as heavy-weave fabric or basketwork have

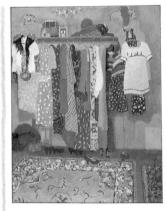

ABOVE Marian Carrigan allows bright colour and pattern variation to delineate form. The choice of subject illustrates the way strikingly original images can be found in everyday situations, if the artist is alert to the design potential of chance arrangements.

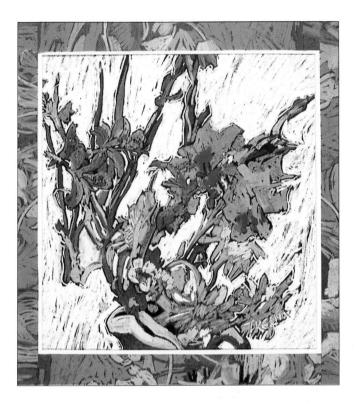

LEFT Frances Treanor has an unerring eye for the pattern quality in natural forms and abstract shapes. She heightens this aspect of her images with a bold approach to colour combinations and expressive handling of the medium. She controls the soft pastel colour across variations between sharp, fluid lines and soft, chalky textures. In this example, she has expertly judged the colourful quality of clean white when it is actively combined with a strong chromatic range.

their own structural pattern resulting from the way they are made which forms a distinctive texture.

The colour values in such elements provide an opportunity to create decorative interest and a busy surface in a drawing that enlivens the overall composition. Patterns can be represented by means of a straightforward analysis of local colours, shape and design, the relation to the light source and the colour variations created by tonal emphasis. The technical methods you use for this aspect of the image do not necessarily differ from those that you use throughout the drawing process. There are, however, particular techniques which can be employed for such decorative elements, the white line technique described earlier being one such method. An interesting alternative for building up surface texture and pattern is the technique known as "resist", the basic principle of which is combining materials that do not blend physically.

The most obvious example of a resist is a combination of oil and water. If you draw with wax crayon or oil pastel and then lay a watercolour or ink wash on top, the greasy surface texture of the drawn marks rejects the fluid medium, which runs off without affecting the original colour and settles only on the surrounding areas of paper. The separation of colours is most pronounced between a greasy and fluid medium, but interesting effects can be made by combinations such as hard waxy and soft crumbly coloured pencils, or wax crayons overlaid with the powdery colour of soft pastels. These act in a similar way, but often with a more muted, subtly modulated effect because the colours do intermix slightly. The results of

ABOVE Moira Clinch develops a range of organic textures within a geometric structure, using coloured pencil shading gradually built up to an intense variation of hue and tone. The contrast of cracked and broken textures against fluid colour gradation is the more effective for the consistency of the drawing technique.

129rb

129rt

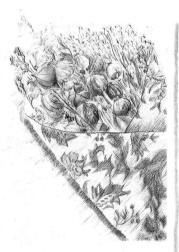

ABOVE Jan McKenzie makes an interesting contrast between a sheaf of subtly coloured natural flowers and the patterned paper in which they are wrapped. The printed pattern is delineated using white line technique.

RIGHT A series of abstractly coloured images was developed by Judy Martin from a photograph of a cat rolling on a patterned rug. She transposed the colour and pattern to the central form, gradually developing a loose interpretation of the image in coloured pencil (top) and pastel versions. such techniques also depend on the direction of the marks and the pressure you apply in laying the colours. Resist methods should be tested out before you introduce them into a particular drawing so that you can be sure of the results.

"Inventing" You can choose to introduce pattern elements where none exist in reality, thus turning a relatively simple subject into a riotously colourful image. To allow the patterns or textures their full impact, it is advisable to work within fairly simple constructions of shape and form. A still life, for example, could be treated as an outline drawing and each area filled with a pattern element, changing the forms of the patterning across individual shapes. An interior might be reduced to an arrangement of angled planes and curves with blocks of pattern and texture creating the spatial sense of the design. An interesting way to develop this idea of decorative surface pattern is to use scraps of printed paper from colour magazines or pieces of wallpaper or fabric, to create a collaged composition, which you can then use as a basis for developing drawn marks that work in a similar way. RIGHT Elisabeth Harden has constructed this boldly patterned image with collage pieces of painted paper, simplifying the main forms into flat, interlocking shapes. The paper edges create structure and depth, and this is emphasized by the arrangement of the different elements, with the detailed textile pattern in the background offset by the more organic design of flowers and jug in the foreground.

This use of pattern can also be tied to real form by studying the subject in terms of its tonal values and creating pattern equivalents for each range of the tonal scale. Working in this way, you should be able to read the finished drawing as having three-dimensional form and space corresponding to the elements of depth and volume in the subject.

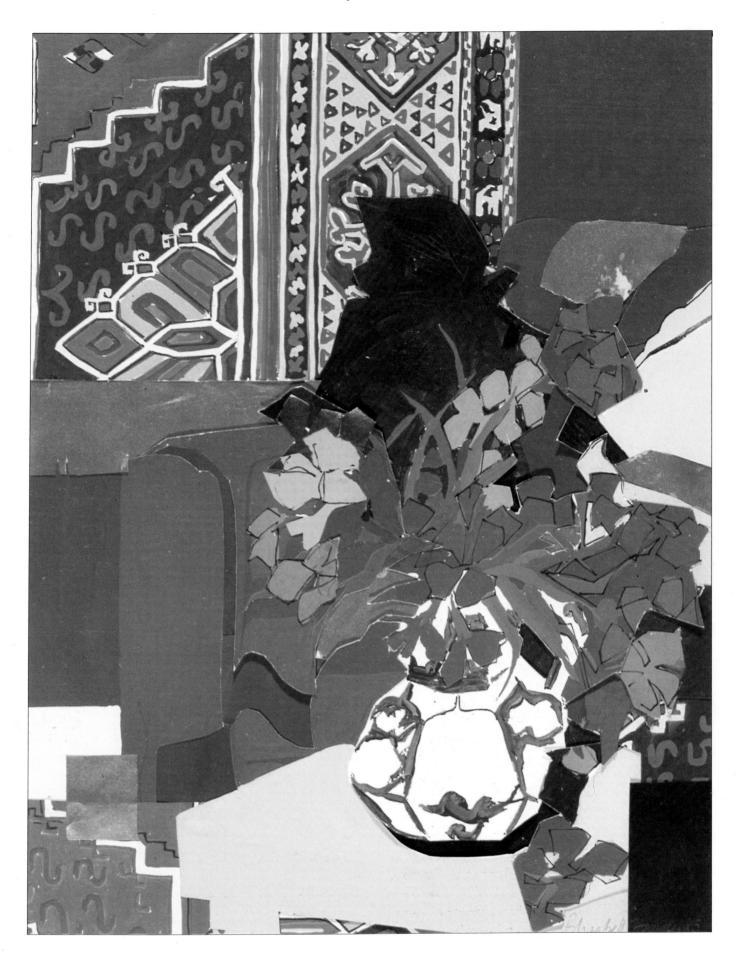

Figures in motion

To arrest the motion of a figure and catch some essential quality of the movement is a test of the artist's ability to coordinate what the eye sees with what the hand draws. The way to encourage this ability initially is to make dozens of sketches of moving figures, very roughly and in some detail, as the opportunity presents itself. If you have access to life classes, you can make use of a studio model, but there is plenty of visual stimulation to be found in day to day situations if you get into the habit of "people-watching".

This range of drawings covers both possibilities – repeated sketches of a single model and quick studies of random gestures and patterns of movement. The colours are used to enhance the expressive qualities of movement, ranging from simple brush-line drawings in a restricted colour range to more complex crayon, ink and watercolour studies.

The idea is to develop an uninhibited technique, picking up the details of the pose or gesture and dashing them down quickly to create a characteristic image. It does not matter if your first results are crude or inaccurate. With continuing practice, you will develop more confidence in translating what you see into drawn marks that economically capture the essence of the subject.

132

CONVEYING MOVEMENT

Many drawings have a sense of movement that comes from the movement of your hand as you make marks with the drawing tools. Certain subjects naturally suggest mobility notably human figures and animals — that can lend a dynamic force to the drawing even when the model is in a static pose. The problems of rendering actual movement — as of a figure crossing a room, dancing, or performing any definite action — have been tackled in various ways by different artists. There are a number of visual conventions which you can use to convey a sense of movement, depending on the context suggested by the subject and the qualities of picture surface you want to achieve.

ABOVE Linda Kitson precisely conveys the sudden spurt of energy of a cricketer breaking into a run. The forward thrust of the pose is captured in the vigorously brushed line, the shifting weight of the body emphasized by the transitions through heavy patches of dark and light colour. The whole image is given its sense of speed and energy by the loose brush drawing technique.

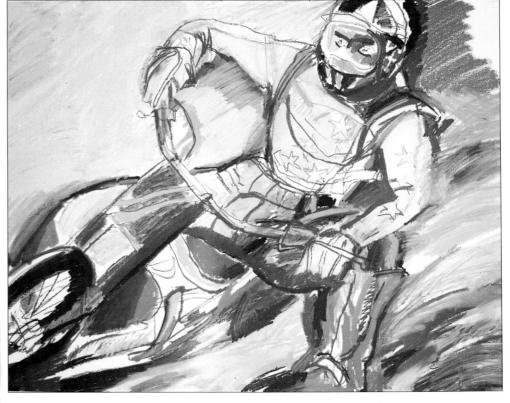

The visual attraction of movement is its quickness and fluidity — the choreographed rhythms of a dancer, the accidental grace of a cat washing itself, the constantly changing patterns of people walking along a busy street. If you could slow these things down enough to see what is really going on, the unique, attractive characteristic of the activity would already be lost.

Making a drawing of a subject in motion is a matter of memory as well as observation, since even as you begin to mark down what you see, the subject has moved on. This changeability is confusing. You have to develop an almost instinctive process of allowing the evidence of your eyes to be translated easily into drawn marks. In this way you form the ABOVE Loose washes and scribbles of paint are overlaid with a powerful pastel line in Linda Kitson's portrait of a speedway biker. The way the line swings around the form, breaking open and then hardening into heavy slashes of colour is appropriate to the tough character of the sporting subject and the unified movement of man and machine.

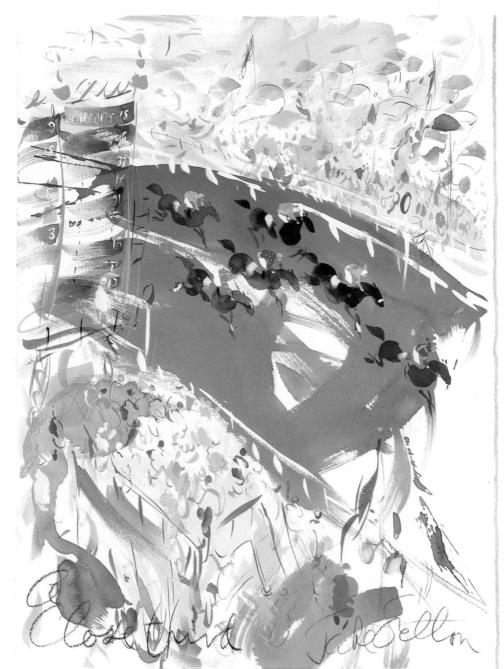

LEFT Jake Sutton's watercolour relays the excitement of a crowded race track as the race nears its finish. The horses and riders are just vivid dashes of colour leading through the image, the busy activity of the crowd merely suggested, but these elements are so aptly though minimally described, the whole impression is remarkably illustrative of the atmosphere.

ABOVE Pauline Turney uses the rippling quality of printed-off colour to capture the image of a swimmer breaking surface. White patches flickering through the colours highlight the wet figure and its reflection on the water.

solution directly by the activity of drawing not by thinking about how to draw. One way of breaking yourself in more slowly to this process is to ask someone to model repeated movements for you, so that you gain a sense of the patterns of line and form of which the motion is composed. Animals tend to make repetitive movements, though sometimes you have to wait a while for the same sequence to occur again. Confined animals often follow set patterns of movement, so if you don't object to the ambience, the zoo can be a useful place for studied observation of moving forms.

Because it is difficult to track movement visually it is tempting to use photography to "freeze" the motion — but freeze is exactly what it does, and although photographs can make useful reference, they are not a solution to this problem. Serial images, such as the famous sequences of human and animal motion produced over a century ago by photographer Eadweard Muybridge, give information about stages of movement. But there is still the question of how to interpret a series of still images in a way that describes the whole motion pictorially. One way is to "telescope" the movements into a series of connected or overlapping forms.

It is often useful to create a framework for the drawing within which you can plot moving elements of the image and play them off against fixed reference points, including vertical and horizontal stresses. The flat planes of the walls and floor in a room, for example, form a natural "grid" for plotting the way a figure moves within the space.

Linear movement The calligraphic quality of line drawing is particularly appropriate to rendering movement. Sometimes you can obtain a vivid impression of mobility from a simple outline. An important feature of modern calligraphy is an emphasis on variations between thick and thin line (think of the fluid quality of italic handwriting) and this is also a useful device in drawing. The qualities of a line that alternately swells BELOW The movement in this pose is given emphasis by the way the light and dark contrasts are blocked across the squared shape created by the bending figure with arm outstretched. A more fluid rhythm is set up along the curving patterns of the striped towels, and Sally Strand takes the opportunity to introduce vivid colour accents, offsetting the warm flesh tints and neutral background tone.

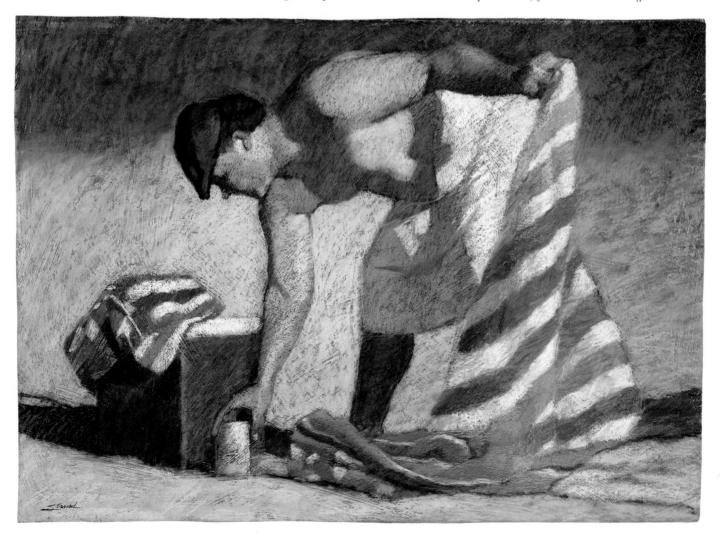

and tapers as it traces out a form suggest a changing balance of weight and direction that implies movement.

The technique described as "nervous" line, or repeated lines, takes a different approach, using broken lines or interwoven tracings to sketch out the form. This sort of technique successfully conveys limited movement — the gradual shifts of position of a seated person relaxing in a chair, small hand and arm movements made during conversation, and so on. It can also set up rhythms and tensions in the drawing that could be used in illustrating athletic or dance movements. Another linear technique that produces interesting results employs dashes and scribbled marks to build up a sense of mass.

In all these techniques, colour qualities can also be exploited to add to the sense of weight and direction in the image. A strong colour, such as a bright red or blue, gives more dynamic emphasis than a lighter yellow, say, or a subtle mixed hue. In linear drawing of movement, the figurative colour values of the subject can be subordinated to a more abstract sense of colour that gives the drawing its own vitality. Coloured lines crossing or running into each other where shapes are formed relating to different elements of the subject strengthen the internal rhythms of the drawing. ABOVE Jake Sutton picks out the essence of acrobatic movement in a single figure study. He chooses the most expressive lines of the figure and uses these as the central axis of the image. The whirlingribbons flying out in all directions suggest a continuous motion of which this image represents only one split-second element. By simplifying the form of the figure, he produces an anonymous but entirely characteristic portrayal of the acrobat.

LEFT Simon Lewty's drawing, in ink, crayon and acrylic on heavy paper, is like a complex map of the artist's concept of subject and image. He mixes abstract, stylized and cartographic forms to develop an internal narrative combining verbal and visual elements.

Direction and mass A composition depicting two or more figures offers the opportunity to introduce movement by setting up directional tensions between the figures. You might place them in such a way that the pattern of their bodies and limbs forms a series of flowing curves leading a viewer's eyes around the image. They could be angled to create oppositions — leaning towards each other or turning away.

Ideas of movement based on arranging the composition to convey action can be worked out in quick sketches. Brush drawing is a particularly useful technique for describing motion in this way, because of the fluid line and medium. Another device is to offset sharp-focus rendering against softer, even slightly blurred areas of the image, and contrast directional marks with solidly weighted shapes. This is particularly useful for including a sense of movement within the broad framework of an image—a street or beach scene, for example, which combines static elements with subjects in motion. An architectural background composed of geometric blocks is a very effective foil for directional movement.

To convey the sense of movement in the drawing is thus a matter of technical variation. When working with pastels, crayons or coloured pencils, you can rub the colours with your fingers, "draw negatively" with an eraser into the coloured marks, or spread the colour with a solvent to soften and vary the drawn textures. If using paint, you can apply soft washes or use dry-brush techniques as well as calligraphic movements of the brush tip to develop the complexity of the forms.

NARRATIVE AND INVENTION

Few artists work only in terms of recording the literal appearance of their subjects. Many, in fact, use the cues taken from the real world to develop a highly personal style of imagery including narrative elements and invented forms and subjects. This is nothing new: consider the religious, social and political themes incorporated in the works of master painters across the centuries, as well as the strands of folklore and literature that have provided subject matter for painting and sculpture. In modern times, the Expressionist, Surrealist and Abstract schools of painting have vastly extended the range of pictorial invention. Personal expression is no longer limited by convention — anything goes.

The once-famous response to the drawing styles of artists such as Picasso, Klee and Miró—that "a child of six could do it" — always carried the wrong emphasis. It is not a matter of capability, but of choice. A child uses particular techniques and observations because of a limited experience of life and art, but practising artists choose their means of expression from among a broad range of perceptual experiences and visual skills. A trained artist who draws people as stick figures certainly has a more complex reason for doing so than that he or she can't draw them "correctly".

The point of bringing up this old argument again is to illustrate the fact that just as drawing only what you see restricts your means of expression, so does the idea of working only out of what goes on in your own head, like an

Expressive Colour

inexperienced child. Many artists have moved into pure abstraction via a highly traditional academic training in drawing and painting, including figure work, landscape, still life and the other established subject areas. Some art students have come to grief by jumping straight into abstraction and finding that, because they have no grounding of experience in visual interpretation, before long there is nowhere to go. Self-expression, paradoxically, works best if there is a certain amount of discipline in perceptual and technical skills.

The experience gained by following some of the exercises and projects illustrated in the previous pages — those basic skills of drawing and colour rendering — provides you with a resource that can be applied to any personal idea you have for image-making. Anything can cause an image to form in your mind's eye — a newspaper report, the theme of a poem, play or opera, an event which has actually happened to you or to someone you know, a historical occasion, a fairy-tale. Alternatively, you might want to explore pure colour as a pictorial phenomenon without reference to landscapes, figures and so on. If you cherish a personal vision, there is only one way to make it real — pick up your drawing tools and make a start.

LEFT This riotous carnival image in exotic colour weaves a touch of the sinister and macabre into the brightly coloured proceedings. The free and easy movement of the forms suggested by the flow of the composition and the expressive brushwork is set against the harsher impressions of the snarling leopard mask and totem figures. The scheme of colour contrives a brilliant illumination of pure hues that is simultaneously enlivening and unsettling, in keeping with the overall image. Page numbers in *italic* refer to the illustrations and captions.

A

abstraction 139 achromatic colours 24-5, 27, 71 acrylic paint 19, 40-1, 50, 138 animals and movement 135 anti-cerne technique 127-8 artificial light 82 and shadow 102 atmosphere 89, 120, 135 atmospherics 62, 94-5

B

background colour 83 background tones 111 backlighting 101-2 backlit effect 93 balance 56, 59, 65, 92 adjustment of 110-13 Barnden, Hugh 29, 81 binding agents/medium 32, 34, 35, 36 binding material 34 black 24, 111 black ink line 39, 49 black keyline 128 black outlines 127 blacks and greys, "coloured" 72 blending 43-5, 60 blending and layering 42 Blowes, Annabel 62 blue 23-4 Bomberg, David 122 The Monastery of Mar 7 Bonnard, Pierre 86 Brazell, Derek 124 brush drawing 10, 66, 67, 74, 75, 81, 134, 138 brushwork 23, 29, 41, 46, 48, 66, 86, 100, 120, 123, 139 Bylo, Andrew, sketchbook page 73

С

calligraphy 8, 9, 32, 50, 95, 95 modern 136 calm 124 candlelight 100 Carrigan, Marian *117, 122, 128* cartridge papers 50 Casdagli, Daphne 92, 99 cast shadows 90, 91, 92, 92, 93, 99, 102, 123 and spatial location 70 ceramics 117 Cézanne, Paul 86

Index

chalk 7, 81 children's drawings 107 chroma 24-5 Clinch, Moira 36, 46, 100, 109, 129 Coates, Tom 76, 83 collage 50, 95, 130 paper 50, 86 colour 7, 12, 16-17, 42, 56, 114 abstract use of 125-6 atmospheric 85-105 "bleached out" effect 83 in composition 60-1 creative 18-19, 20-1 decorative 127-30 discordant 118 emotional impact 18 expressive 107-32 high-key 82 interpretation of 109-13 non-naturalistic 124 non-objective 125-6 pictorial significance 18 pure 12, 139 responses to 18-19 colour accents 31, 75-80, 81, 82, 89, 92, 93, 98, 100, 102, 110, 124, 136 colour balance 77, 94 colour blindness 18 colour character 21 colour chemistry, technical developments 7 colour combinations 27, 129 unexpected 117-18 colour contrasts 95 colour cues 15, 80, 89, 91, 96, 124 colour density 43, 56, 89, 117 colour drawing, advantages and disadvantages of 42 colour drawings, capture visual attractions 55 colour exercises 20 colour families 21, 34, 81 colour gradation, marker ink 45 colour harmony, 19, 25-7, 26, 116 colour information, every-day 118 colour intensity 25, 93-4, 113, 122 colour interactions 15, 88, 99 and the colour wheel 25 colour keys 50, 81-3, 98, 122-3 colour layers, integrated 44 colour links 122 colour mixing 31, 41-53, 58, 83 felt-tip or marker ink 38 linear techniques 45 no fixed formula 42-3 colour neutrals 27-8 colour patterning 127 colour perception 16, 18, 20, 27, 31 colour preference 118 colour primaries, synthetic 25 colour profiles 22-5 colour quality 26, 81, 104, 137

of materials 45 in shadows 91-2 colour range 16, 67, 81, 99 colour relationships 19, 25, 52, 82-3, 88, 117, 126 colour schemes 81, 81, 117-18 colour sensation 18, 24 colour spectrum 16 colour temperature 28-9 colour tensions 116-17 colour test 27 colour theories, now broadened 27 colour values 6, 15-16, 20, 20, 21, 42, 71, 88, 91, 96, 99. 103. 129 adjustment of 111 and atmospheric perspective 87 fixed, no actual standard 21 hue, tone and intensity 25 influences on 62 intensified 119 limitation of 112-13 not fixed 22 of shadow areas 100 single, dense 113 strong 23 transparent 40-1 colour visuals 37 colour washes 45, 48, 49, 75, 90 colour weight 26 colour wheel 25-9, 116 colour-drawing materials 7-8 coloured pencil drawings/sketches 10, 26, 31, 34, 52, 55, 56, 62, 81, 104 coloured pencils 9, 10, 25, 32, 34, 35-7, 36, 42, 43, 44, 78, 99, 124, 138 and paper colour 50 water-soluble 37 colour, low-key 120 colouring agents, chemically developed 23 colouring materials, behaviour of 16-17 colours 19, 58, 98 achromatic 24-5, 27, 71 cool 28-9, 122-3 dominant 83 gentle 121 manufactured 24 neutral 29, 71, 75, 111 overprinted 58 primary 21, 41 pure 21 secondary 21 subtly related 24 transparent colours 37 warm 28-9, 122-3 warm and cool 118 complementary colours 25-6, 26, 27 complementary contrast effect 27, 27 composition colour in 60-1 establishment of 62 planning of 58-66, 64, 74

composition exercise 67 compositional cues, in landscapes 87 compositional planes 66 compositional rhythm 109 compositional structure 7, 70, 88, 89 interiors 98-100 Constable, John 86 contour 126 and volume 69 contrast and harmony 25 contrasts 88, 118, 122, 136 crayons 9, 35, 69, 82, 100, 104, 138, 138 cross-hatching 43, 44, 46, 78

D

dappled light 92, 93 David, Madeleine 31, 34 daylight 100, 104 Dean, Graham 85, 107 delineation (use of line) 8 depth cues 100 design in drawing 64-6 diagonals 60, 61 direction and mass 138 dominant colour 89, 113 dots, dashes and scribbles 48-9 dragging 60 drama, sense of 119 dramatic mood 101, 112 draughtsmanship 7, 10, 29, 123 drawing 6, 8, 9 and harmony 118 drawing inks 10, 38-9 drawing and painting techniques, cross-over between 40 drawing pens, interchangeable nibs 39 drawing "practice" 56 drawing tools and techniques 42 drawings 8, 58-9 large-scale 19 a record 111 small-scale 10 tonal scale and illumination 91 drawn marks gestural quality of 49 influence of texture and shape 118-19 dry linear drawing media 40, 50 dry-brush technique 90, 138 Dunstan, Bernard 6

E

earth colours 22 edge qualities 64, 88 Emsley, Sue *86* energy 124, *134* enhancing effect 25-6, *26* Eyton, Anthony *9*

F

fabrics 103, 117 felt-tip fine lines 38 felt-tip pens 9-10, 37-8, 45, 46, 67, 86, 87 felt-tip sketches 27, 59, 69, 124 figures 57, 59, 74, 112, 132 firelight 100 fixatives 32, 37 slows colour degradation 37 focal points 77, 89, 99 focus and motion 138 form 12, 87-8, 94-5, 123 sense of redefined 113 and space 69-70 framing the image 66

G

gardens 91, 96 Gauguin, Paul 109 geometric lines 81 George, Adrian 69, 102 Gilbert, Ellen 26, 58, 81, 98 glass textured 103 tinted 80 gouache 40, 52, 95, 111, 112 opaque 41, 46, 50 gouache drawing/sketches 62, 89, 90 gouache painting 93 gouache study 100 graphite 81 green 23 grey 29 coloured 28 neutral 25, 27, 111 Gwynn, Kate 111, 112

H

Harden, Elisabeth 62, 69, 95, 130 harmony, contrast and discord 116-19 hatched colour blocks 46 hatching 31, 32, 38, 42, 44, 45-6, 66, 67, 72, 78, 85, 86, 98, 102, 121 Heindorff, Michael 128 high viewpoint 31, 60, 87 highlights 10, 34, 43, 69, 80, 83, 89, 99, 100, 104, 122

colour shifts in 71 intensity of 100 white 42, 76 Hoare, Mike 65, 71 Hockney, David 10 Hogarth, Paul 61 horizontal detail 102 hues 23, 56, 109 fusion of 89 mixed 43 muted 111 pale 72 primary and secondary 23, 25 pure 26, 29, 34, 123, 139 standard 21 hues and tones 31, 42, 69, 91 balanced 88 mixed 42, 44

I

illumination 10, 16, 22, 89, 91, 94 imbalance, unexpected 119 Impressionists 86 Ingres paper 49 ink 38, 50, 110, 123, 138 ink washes 45, 81, 129 insect dyes 22 interior light 6, 98–103, 104 interiors 29, 100 atmospheric effects in 100–2 shadowed 82 variety of light and visual mood 98 with windows 103 internal activity 112 "inventing" 130

K

Kitson, Linda 123, 134

L

lamplight 100, *104* landscapes *12, 15, 24, 40, 46, 49,* 57, 59-60, *71,* 74, 88, 91, 94, *112,* 122 altering mood of 121 and atmosphere *71, 86* colour accents 76 reflected colour 80 sunlit 82 urban *124* lapis lazuli 23 layered colours *86* layered marks 36 layered washes 94, 95 Lewty, Simon 138 life drawing in colour 114 life studies 6, 67, 114 light, 16, 69, 71, 90 afternoon 90, 96 artificial 82, 100, 102 clear 121 concentration of 100-2 evening 96 exterior 96 flickering 93 hard 90 interior 98-103, 104 morning 92, 96 natural, changes in 89 night 90 overhead 100 reflected 60, 67, 69, 77, 100, 103 shimmering 122 strong 100 summer 120 vibrant 31 warm 71, 124 winter, 82, 98, 100 see also candlelight; dappled light; illumination; sidelighting; sunlight; white light; window light light and shade 56, 66, 67, 69, 89, 93-4, 96, 100 light source 69, 80, 93, 98, 100, 104 light wavelengths, reflection and absorbtion 16 lightness and darkness, tonal values 21 line drawing brush and pen 75 coloured inks 52 and watercolour wash 61 line and mass 56, 112 line and tone 26, 67 line work 34, 35 linear drawing techniques 6, 46, 136-7 linear movement 136-7 linear patterns 59, 87 linear qualities 8 linear texture 32 liquid watercolours 38 lithographs 58, 67, 69 local colour 16, 39, 61-2, 64, 64, 66, 67, 71, 75, 77, 91, 98-9 altered perceptions 100 luminosity 93-4

M

McKenzie Jan 42, 43, 44, 56, 130 marker colours 32, 45 markers 9–10, 37–8, 50, 83, 87 Martin, Judy 19, 46, 64, 81, 90, 93, 95, 109, 110, 111, 126, 130

Mason, Debbie 107 mass and volume 56 materials 9-10, 58 colour values and surface textures 31 reflective 80 understanding of 12 Matisse, Henri collage 50 Red Studio 18 media 32-41 Milne, Vincent 70, 90, 112 mineral pigments 22, 23 mixed media work 42, 50, 92, 112 mobility 134, 136 monochrome drawing 6, 56, 67, 69 moods altering emphasis of 121 creation of 119-25 languid or active 123 mysterious 123 qualities of 121-2 motion, continuous 137 movement 26, 49, 102, 123, 127, 132, 134-8, 136, 137, 138, 139

N

narrative and invention 138–9 natural features 87 natural forms, pattern quality 129 natural subjects 26, 116 natural world, colour cues 124 negative drawing techniques 34, 127–8, 138 negative effects 43 negative forms in composition 56, 64 nervous line technique 137

<u>o</u>

objective drawing, and tonal variation 69 observation, rapid 89-91 oil paintings 29 oil pastel sketches 45 oil pastels 15, 34, 34, 42, 43, 44, 50, 70, 99, 119, 129 oils 7 optical effects 88 orange 22 outline and contour 56 outline and silhouette 64

Ρ

paint brushes, for ink drawing 39 "painted drawing" 10 paints 10, 39-41 paper 6, 10, 50, 120, 122 coloured 10, 49-50, 52 dark-toned 12, 83 grain of 12 heavy 138 potential of 31-2 smooth-textured 50 texture and graininess 43 tone and texture 42 pastel colours 60, 90 pastel drawing 58, 76 using coloured paper 49, 83 pastel drawings/sketches/studies 72, 89, 93, 95, 109 pastel pencils 32, 32, 34 pastel sticks 32 pastels 6, 9, 12, 19, 25, 27, 32, 32, 34, 49-50, 50, 52, 69, 78, 83, 90, 93, 102, 109, 120, 138 blending of 44-5 medium and hard 32 soft 32.32 textural quality 20 pattern and texture 56, 127-30 patterns 104, 129 pen drawing 45 pen and ink drawing 32, 34, 64 pencil line drawings 48 pens and drawing inks neglected 38 perspective 87 atmospheric (aerial or colour) 87-8 deep 77 linear 87 photography, and motion 135-6 pictorial elements 58 pictorial invention 138 pictorial themes 107 picture plane, division of 61 picture-making, a logic of 126 pigments 22, 32, 71 synthetic 7, 22 plant dyes 22, 24 Plumb, John 26, 60, 90 points of reference 124 portraits 107, 110, 122, 124 Potter, Ashley 15, 100 purple 24

paintings 117

R

recession 29, 29 red 22 reflected colour 71, 80, 92, 98 reflected light 60, 67, 69, 77 reflections 24–5, 80, 87, 109, 135 reflective colours 22 relative value scale 99 resist techniques 34, 55, 75, 129, 130 Ribbons, Ian *39, 74, 75, 77, 90, 110, 120, 121, 123* Robb, Tom *46, 59, 66, 67, 69, 72, 82, 86, 89, 119* room design, conscious colour accents 76 Rothchild, Judith *32, 58, 93, 103*

S

scale, limited, creative factor in image-making 10 schematic representations 69 scribbling 32, 46, 48-9, 66, 78, 94, 120, 121, 127 self-expression 108-9, 139 self-portraits 109 sensations, testing of 125 serial images 136 shading 31, 34, 38, 43-5, 44, 49-50, 67, 77, 129 shadow patterns 92, 92-3, 96 shadow play 102 shadows 10, 29, 61, 66, 69, 69, 72, 76, 82, 83, 85, 89, 90, 91, 100, 120, 123, 124 colour shifts in 71, 77 shapes 66, 102 shellac 39 sidelighting 100 Simpson, Ian 48, 49, 56, 98 sketches 37, 37-8, 72, 74, 91 preliminary 83, 90-1 to capture movement 138 Smith, Stan 112 smudging 32 soft pastel textures 31 space 29, 87-9, 98 still life 27, 50, 55, 57, 59, 66, 116, 117, 119, 130 white 78-9 stippling 32, 43, 45, 46, 48, 72, 94 Strand, Sally, 31, 120, 136 Men in White 76 street markets 119 street scenes 119 stresses 59, 62, 102 Strother, Jane 15, 24, 40, 50, 55, 85, 87, 116, 119 structural detail 52 structuring, and interior light 98-100 studies, detailed 74 sunlight 58, 82, 85, 100 surface effects, influenced by quality of light 89 surface pattern and texture 128-30 surface qualities 69-70, 77, 123-4 surface texture 43, 71, 88, 94 surfaces 76, 77, 78 Sutton, Jake 23, 41, 135, 137 symmetry 56,65

Т

Tarrant, Olwen *12* technical skill 56

techniques 10 variations in 42 tension 88 tertiary colours 27-8, 29 texture 9, 12, 34, 42, 45, 50, 60, 67, 69, 70, 75, 90, 107, 112, 128-9 broken 70, 83 of pastels 44-5 pronounced 77 rough, of wax resist 55 textured colour 98 thinking in colour 56-8 Tillyer, William 95 time and season 89-94 tissue paper, translucent 50 tonal balance 26, 50, 69, 82 tonal contrasts 29, 70, 87, 88, 89, 96, 111, 122, 123 heightening of 119 of light and shade 62 and sidelighting 100 tonal counterpoint 102 tonal gradation 102 tonal keys 69, 80, 112 tonal modelling 77 tonal patterns of subject, broken down 71-2 tonal range 71 tonal scale 76,91 tonal shading 77 tonal study 102 tonal values 21, 26-7, 29, 44, 55, 66-74, 69, 75, 81-2, 88, 98, 126 and atmospheric perspective 87 and colour weight 26 and pattern 130 reversal of 118 tone 66-7, 117 and colour 70-2 tones 58,81 dark 80 graded 43 light 72 Toulgouat, Jean-Marie 124 townscapes 48, 59-60, 75, 91, 94, 111-12 collaged 52 transient effects 89-91 translucency 35, 36-7, 90 Treanor, Frances 20, 129 Trevelyan, Julian 55 Turner, Joseph M.W. 86 Turney, Pauline 83, 89, 135

UV

Upton, Michael 29 Van Gogh 19, 113 viewpoint 58, 60, 62, 65-6, 92 views, angled 101 visual analysis 56 visual conventions, movement 134 visual cues, lack of 94 visual impression 8, 80 visual information 57-8 visual perception 55 visual sensations, of light and colour 16

WY

warm/cool contrast 93-4 water-soluble inks 38 watercolour 40, 42, 43, 50, 74 over wax 95 watercolour drawings/sketches/studies 41, 49, 65, 82, 90, 98, 107, 120, 121, 135 watercolour washes 38, 39, 40-1, 45, 55, 61, 62, 74, 104, 128, 129 watercolours 83, 85, 95, 99, 110, 111, 123 wax crayons 34, 129 wax drawing 55 weather conditions, and local colour 62 white 24-5 white light 16, 71 white line technique 128, 129, 130 window light 100 windows 102-3 woodscape 82 working drawings 62 yellow 22